W9-AKX-466

IMAGES
of America

CHESAPEAKE BAY
STEAMERS

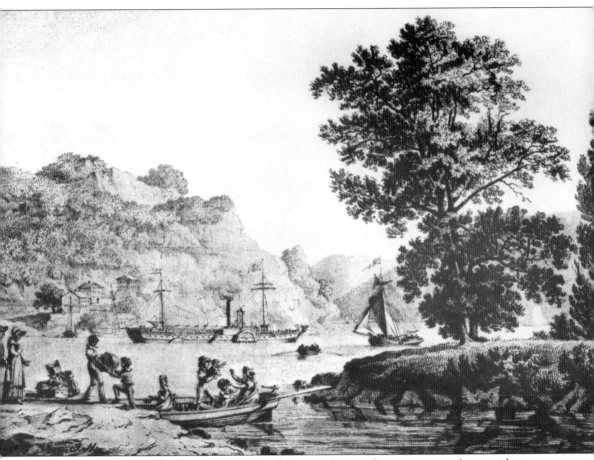

Robert Fulton's paddlewheel steamer opened the era of steam-driven passenger boats with a journey from New York City and up the Hudson River to Albany on August 17, 1807. In November of that year, Fulton wrote in a letter that proposed a second steamer, "after all accidents and delays our boat has cleared 5 per cent on the capital expended and as the people are not discouraged but continue to go in her at all risques, and even increase in numbers I think with you that one which should be complete would produce us from 8 to 10,000 dollars a year or perhaps more and that another boat which will cost 15,000 dollars will also produce us 10,000 dollars a year." The boat is historically known as the *Clermont*, a name probably never used by Fulton, who referred to it as the *North River Steamboat*. Fulton described it in another letter as "150 ft. long, 13 ft. wide, drawing 2ft. of water . . . running 4 miles an hour." (Mariners' Museum.)

ON THE COVER: Old Point Comfort, the touchstone of the passenger steamboat era on the Chesapeake Bay, looks out over the Naval Review of 1893. The battleships have come from all over the world, the tug *Britannia* is yet to become a setting for a Jack London novel, and a sidewheel steamer stops in the middle of it all before heading out on a journey between Baltimore and Norfolk. (Hampton History Museum.)

IMAGES
of America

CHESAPEAKE BAY
STEAMERS

Chris Dickon

ARCADIA
PUBLISHING

Copyright © 2006 by Chris Dickon
ISBN 0-7385-4373-X

Published by Arcadia Publishing
Charleston SC, Chicago IL, Portsmouth NH, San Francisco CA

Printed in the United States of America

Library of Congress Catalog Card Number: 2006932171

For all general information contact Arcadia Publishing at:
Telephone 843-853-2070
Fax 843-853-0044
E-mail sales@arcadiapublishing.com
For customer service and orders:
Toll-Free 1-888-313-2665

Visit us on the Internet at www.arcadiapublishing.com

CONTENTS

ACKNOWLEDGMENTS

The impulse to preserve the history of the Chesapeake Bay is as strong as the force of that history since 1607. Library sources for the telling of this tale are the Maryland Department of the Enoch Pratt Free Library in downtown Baltimore, one of America's great libraries; the remarkable Web site of the Library of Congress; the Wilson Historical Room of the Portsmouth Public Library in my own hometown; and the source I've gone to for years of producing history for broadcast and print, the Sargeant Memorial Room of Kirn Library in Norfolk. The Mariners' Museum library in Newport News is an internationally used repository of maritime history and provided all of the information that was left to discover after other sources were exhausted. The Calvert Marine Museum in Solomons, Maryland, offers a thorough focus on the maritime history of the bay. North of Solomons, the Chesapeake Beach Railway Museum re-creates the place and time of the resort and amusement park that thrived there more than 70 years ago, and the Calvert County Historical Society offers its knowledge of the region going back to pre-Revolutionary times. In Virginia, the Essex County Museum at Tappahannock is organizing historical resources of the last 400 years. On the Eastern Shore, three fine historical societies represent the best forces of Virginia history. Parksley, one of America's first planned communities, is home to restored railway cars and the Eastern Shore Railroad Museum. In Onancock, the Eastern Shore of Virginia Historical Society, or Ker Place, fairly breathes with the social, marine, and agricultural history of the shore. And the Cape Charles Historical Society continues to develop a wonderful archive of the history of a small town that played a transforming role in the history of U.S. transportation. The Hampton History Museum opened its files while in the midst of its move into sparkling new quarters, and the Casemate Museum at Fort Monroe unlocked doors and file cabinets in a building surrounded by a moat. Thanks to all for their hospitality and generosity and to Robert Lewis, a private collector in Delaware whose initial contributions to this project encouraged me to get it started. My research was illuminated by the work of author David C. Holly, especially his *Chesapeake Steamboats/Vanished Fleet*, published in 1994 by Tidewater Publishers of Centreville, Maryland. This book was written on the Western Branch of the Elizabeth River in the old office of Hugh Johnston, a man of Portsmouth and the railroads, bridges, and piers of the region. It is dedicated to his memory.

INTRODUCTION

There is no more powerful a geographic source of American history than the Chesapeake Bay.

English settlers first touched ground in the new country on the southern shore of the bay in 1607. Ending their ocean journey in what is now Virginia Beach, they sailed across the lower bay and up the James River to create the Jamestown Settlement. Other settlements followed soon thereafter, some of them becoming the small towns of the 19th and 20th centuries that are pictured in this book. The cities of Norfolk and Portsmouth, Virginia, have their origins in the 1600s, and the upper bay cities of Baltimore and Annapolis, Maryland, not long after that. The bay that lay between them from north to south was at once dynamic and temperate, expansive enough to offer great bounties of food and exploration, but small enough to allow the formation of a community of towns, cities, and resorts that worked together on a quality of life unlike any other in the new country.

The first stirrings of American Revolution and government took place in this watershed. The decisive naval battle of the Revolutionary War was played out not far from the site of the first 1607 landing, as the French prevented the British from entering the bay in 1781. And the bay would go on to know war very well: the War of 1812, the Civil War, and the projection of American naval power out of the bay and into the battles of World Wars I and II.

Through all of those years, water and land blended together into a basket of produce and seafood for the entire East Coast. The cities developed commercial connections between Europe to the east and the rest of developing America to the west. In the early 1800s, the new technologies of motor-driven power set themselves out on the water in the form of steamboats that drew the bay community even closer together while consolidating its commerce with the rest of the world.

The bay steamers first moved through the water with side paddlewheels linked to steam engines beneath single smokestacks, and they used their freedom of easy movement to cover the long distances between North and South relatively quickly. They began to connect with railroads east and west, and by the mid-19th century, there seemed not to be a river or inlet in which they did not travel. As boats, they ranged from engineering marvels to infuriating contraptions. They belched black smoke, often collided, and frequently sank. They switched owners and took on new names at the drop of an anchor. But they brought a way of life to the region that allowed its people to live almost as much on the water as they did on the land.

Near the end of their era, many were drafted into distinguished service in international waters during the Second World War. Some were shot at by submarines, and one in particular played a storied role in the troubled history of postwar Europe. Their steam-driven screws propelled them just past the middle of the 20th century, but not fast enough for the rush of modern times. Transportation needed to move more quickly now. Bridges crossed parts of the bay that before could only be crossed by boats, and railroads that had met the boats at the water stopped running. The steamers reconfigured themselves to carry automobiles, but the cars and their drivers preferred the highways. Finally one night in Norfolk, they disappeared into history. What's left of them rests in the photograph and ephemera archives of the libraries, museums, and historical societies of the large cities and small towns of the bay. The book that follows draws from these sources and tells the story of a magnificent time on beautiful water.

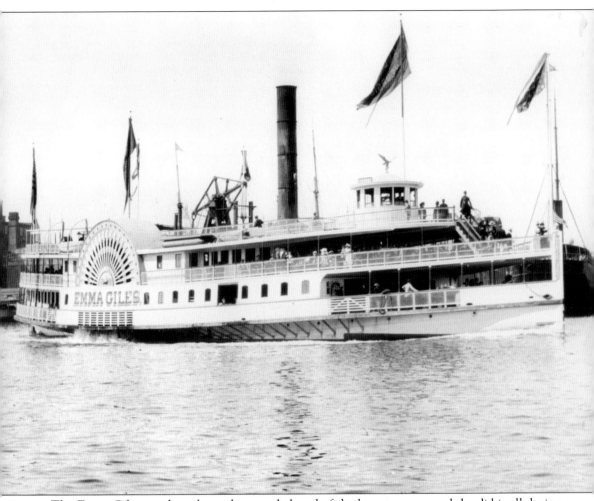

The *Emma Giles* may have been the most beloved of the bay steamers, and she did it all during a half-century starting in 1887. She traveled the bays and the rivers, took happy vacationers to the beaches, and carried people in elegance and animals in her freight holds. Crowds sometimes broke into cheers when she pulled up to the wharves of small towns. (Mariners' Museum.)

One

CITIES OF THE BAY

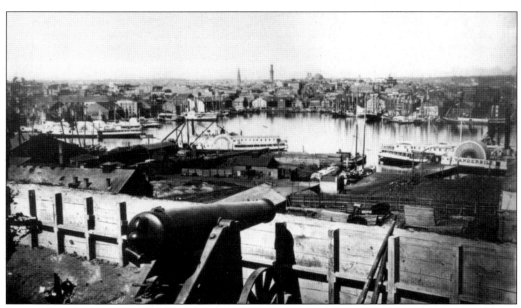

One of the cannons of Fort McHenry overlooks Baltimore harbor in 1862. It had probably last been used in one of the largest battles of the War of 1812 as British ships bombarded the American fort in September 1814. The event resulted in the writing of the "Star Spangled Banner" by Francis Scott Key. The war ended inconclusively, effectively abandoned by both sides, but it sped the launch of the era of the Chesapeake Bay steamers when the first of them, the *Chesapeake*, steamed out of the harbor on June 13, 1813. Prominent in this picture is one of the boats of the Vanderbilt line, probably donated to Union forces in the Civil War by transportation magnate Cornelius Vanderbilt. Vanderbilt had been one of the earliest steamboat entrepreneurs. In the 1840s, he operated a fleet of 100 and was the country's largest single employer. (Maryland Department, Enoch Pratt Free Library.)

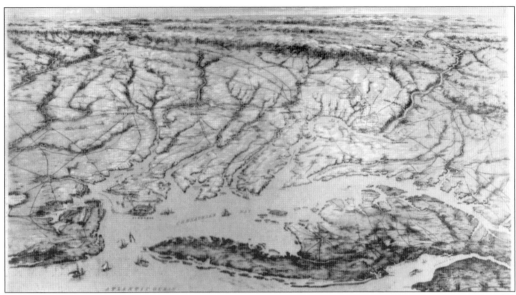

This bird's-eye view of "The Seat of War" published in 1861 encompasses most of the geography through which the steamers traveled. The perspective looks almost due west across the continent. The Atlantic meets the Chesapeake Bay between Norfolk to the south and the tip of the Delmarva Peninsula (Delaware and the eastern shores of Maryland and Virginia) to the north. Hampton, Newport News, and Fort Monroe/Old Point Comfort sit at the mouth of the James River. Washington and Baltimore are to the northwest. (Maryland Department, Enoch Pratt Free Library.)

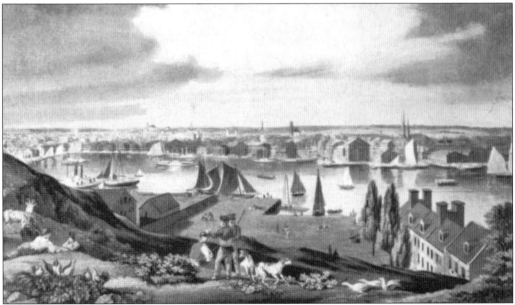

The core of steamer traffic on the Chesapeake Bay would take place between Baltimore and Norfolk. For a time after the War of 1812, Baltimore had been America's second largest city. Both industrial and rural, depicted here in 1850, it was one of the most active American ports, though it sat at the top of the Chesapeake Bay and 150 miles from the Atlantic. (Maryland Department, Enoch Pratt Free Library.)

In 1851, the port of Hampton Roads, at the bottom of the Chesapeake Bay, was a thriving point of water-born commerce and U.S. Naval activity. The city of Norfolk (top left) is seen across the Elizabeth River. The Portsmouth Naval Hospital (bottom right), in the city of Portsmouth, was opened in the 1830s. The steamer *Herald* is depicted heading out for Baltimore with livestock on its foredeck. (Kirn Library, Sargeant Memorial Room.)

These advertisements from the *American Beacon* and *Norfolk-Portsmouth Daily Advertiser* of August 5, 1823, document the first years of steamboat travel between the cities of Norfolk and Baltimore and other cities and rivers of the bay. The advertisement for the *Potomac* describes connections that were made between the bay and inland towns by horse-drawn stagecoach. (Wilson History Room, Portsmouth Public Library.)

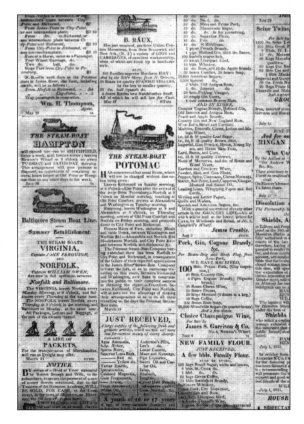

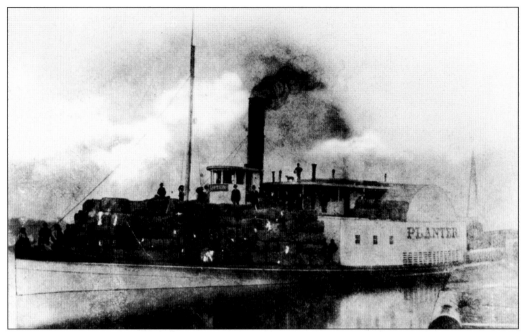

One of the earliest photographs of a bay steamer shows the freight and passenger boat *Planter*. Built at Charleston, South Carolina, in 1860, she is shown here with a cargo of 1,000 bales of cotton. In the 1850s, steamers averaged 230 feet long, 30 feet wide, and 11 feet deep. *Planter* became a significant ship of the Civil War, used by both sides. (Mariners' Museum.)

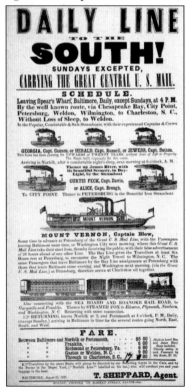

An advertisement dated 1847 offers a wealth of information about the use of steamers in the bay to travel between its major cities and make connections by rail to inland towns. It also reflects the importance given to the steamer captains, many of whom became celebrities of the region. Safety records were often a selling point because the boats were easily subject to fires and collisions. (Library of Congress.)

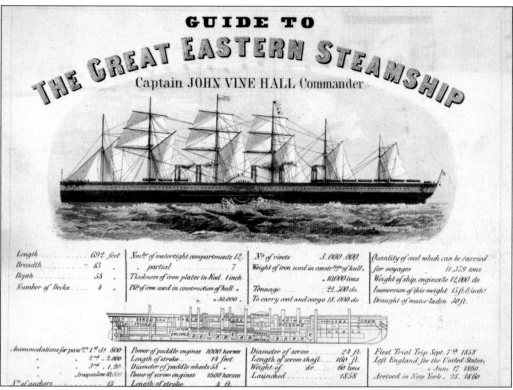

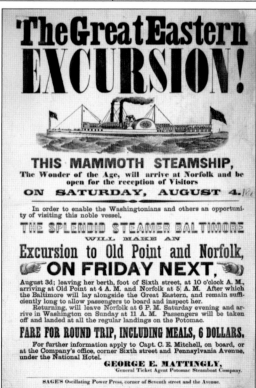

Steamboats were the transportation marvels of the early 19th century, and in 1860, the English sail and steam vessel *Great Eastern* was known as the largest in the world. "Her coming to the United States was a great event in the whole country," recalled Joseph Seth in a 1926 oral history, "her entry into New York harbor a triumph. Norfolk gave her a great reception. So when she sailed up the Chesapeake she was eagerly looked for and there was great excitement on the Eastern Shore." (Library of Congress.)

The log of the *Great Eastern*'s trip up the bay records: "On our way we passed several vessels, the crews of which lustily cheered us as we steamed by; two steamers from Baltimore crowded with people to meet us, and the advertisements had it to accompany us up to our anchorage. They had the presumption to try their speed with us, but by the time we anchored a faint line of smoke on the horizon marked their 'whereabouts.' " (Library of Congress.)

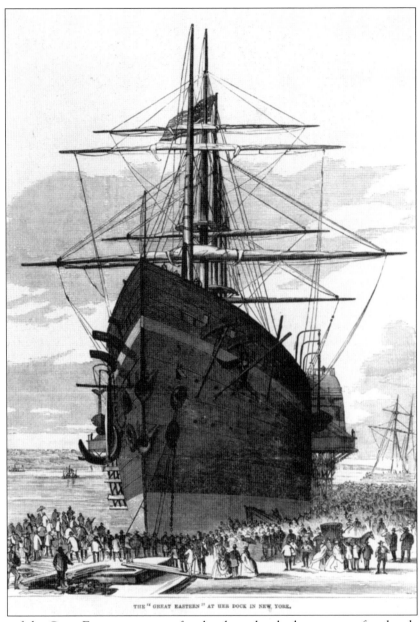

THE "GREAT EASTERN" AT HER DOCK IN NEW YORK.

The story of the *Great Eastern* was one of technology that had gotten too far ahead of its age. She was to have been named SS *Leviathan*, but her high initial cost bankrupted her first owner. Renamed, she was the first boat to be built with a double-skinned hull, though the second double-hulled ship would not come for another 100 years. She could not use sails and steam at the same time because engine exhaust would set the sails on fire. Known as an "unlucky ship," two workers were killed during her launch and six more in a subsequent boiler explosion, and there was a rumor about a skeleton lodged between her hulls. She was too large for many harbors, and her passenger and freight capacity exceeded the needs of the international market. Converted to a cable-laying boat, she put down the first transatlantic cable from Newfoundland to Ireland, followed by others in the Atlantic and in the Arabian Sea. Her last job was as a floating billboard, and she was scrapped in 1888. (Mariners' Museum.)

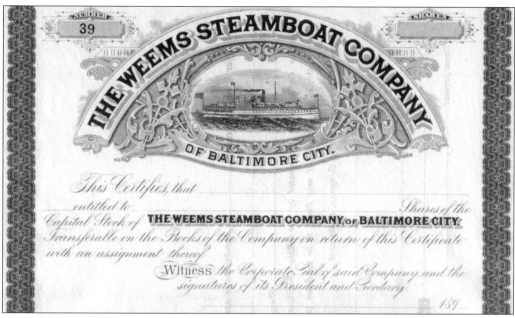

NUMBER
39

THE WEEMS STEAMBOAT COMPANY

OF BALTIMORE CITY.

This Certifies, that ___

___ entitled to ___ Shares of the

Capital Stock of **THE WEEMS STEAMBOAT COMPANY, OF BALTIMORE CITY.**

Transferable on the Books of the Company on return of this Certificate

with an assignment thereof

Witness the Corporate Seal of said Company, and the

signatures of its President and Secretary.

One of the most successful steamboat companies was founded by Capt. George Weems in 1817. His first boat had been captured by the British in the War of 1812, but he was determined. Despite early adversity, including a boiler explosion that led to the near amputation of both legs and kept him from piloting his own boats, he put in business a company that lasted until 1929, though in its last years, it was a subsidiary of the Pennsylvania Railroad. (Calvert County Historical Society.)

The Civil War (1861–1865) brought tremendous crosscurrents to the steamer business on the bay and its rivers. Maryland and Virginia were technically at war, and passenger/freight travel continued only sporadically. Until 1862, *Planter* was a Confederate ship, but her pilot, Robert Smalls, was a slave. On May 13, 1862, Smalls and a crew of fellow slaves, with a few women and children, ran the ship through a Confederate blockade and delivered her to Union forces. She became a medical supply boat, seen here at City Point (later Hopewell), Virginia, on the James River during the siege of Petersburg in 1864. (Library of Congress.)

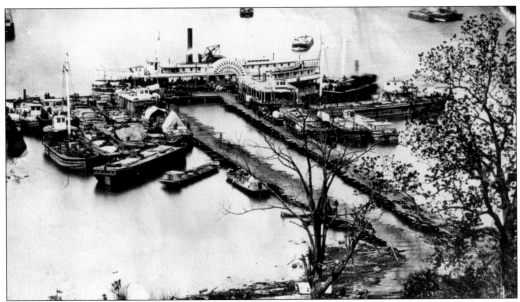

A wider view of City Point shows an active port and army camp during the Civil War. The *George Weems* is unloaded at the end of a long pier shared with the canal boat *Clinton*. At the time, canals were a developing mode of transportation to inland Virginia. The James River and Kanahwa Canal, for example, was conceived by George Washington and eventually extended nearly 200 miles from Richmond to Buchanan, near the West Virginia and Kentucky state lines. (Mariners' Museum.)

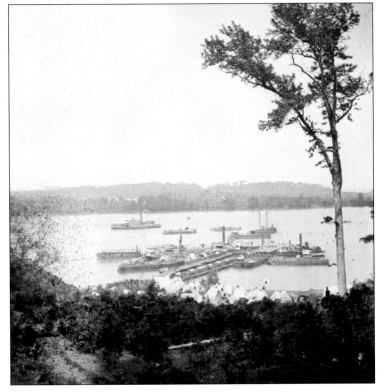

Covered wagons line the piers leading to steamboats at Belle Plain Landing on Potomac Creek near Fredericksburg, Virginia. The original wharf at Belle Plain dated to 1814 and had been written about by Charles Dickens in his *American Notes*. In 1864, Union forces added pontoon piers and converted the area into a major supplies depot and a place for internment of Confederate prisoners. (Library of Congress.)

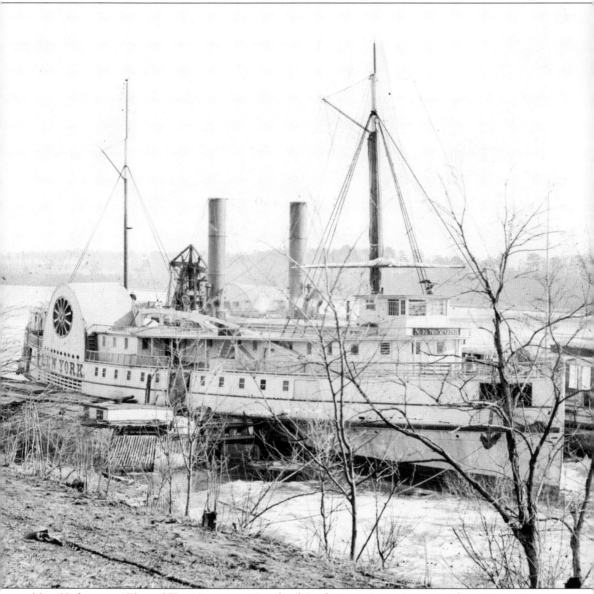

New York was a "Flag of Truce" steamer involved in the ongoing prisoner exchange programs of the Civil War. Though not always followed, the agreement between the two sides called for exchange or parole of prisoners after 10 days of capture. The formula for exchange ranged from one general for 46 privates to one non-commissioned officer for 2 privates. The *Philadelphia Press* of October 21, 1864, carried the headline: "FORTRESS MONROE, *ARRIVAL OF 550 PAROLED PRISONERS FROM RICHMOND*. The flag of truce steamer *New York*, in the charge of Lt. Col. J. E. Mulford, arrived from Aiken's Landing at five o'clock this afternoon, with five hundred and fifty prisoners of war, paroled." The article went on to name paroled officers by name, rank, and function, but not the privates involved. The use of commercial steamers in the Civil War would predict their use in a limited way during World War I and extensively in World War II. (Library of Congress.)

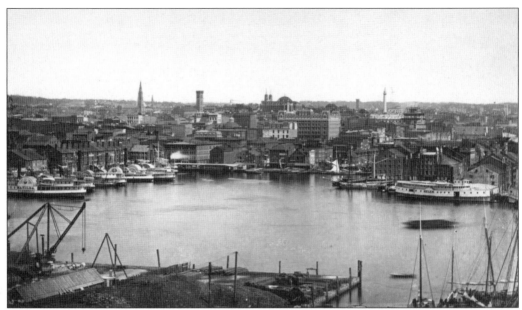

The end of the Civil War brought a boom in commerce on the Chesapeake Bay, and Baltimore harbor once again thrived with commercial traffic. In 1872, the Baltimore and Virginia Steamship Company (a Weems subsidiary) was operating full steam with boats like the *Matilda*, far left, running to Virginia's Rappahannock River. The *Helen*, far right, was built in 1871 for the Eastern Shore Steamboat Company. The boats were also called "Packets," a maritime term for boats or ships with specific purposes and schedules. (Maryland Department, Enoch Pratt Free Library.)

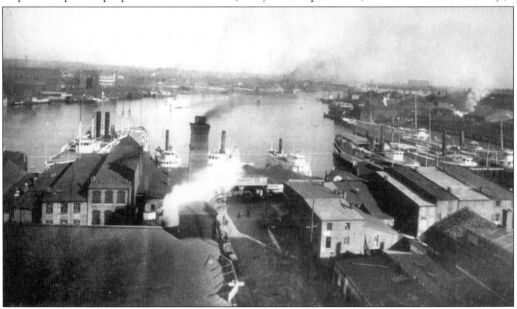

Steamers swarm the Light Street docks in Baltimore in 1895. The *Louise*, right of center at pier 15, was a popular boat of the Tolchester Line, which ran between Baltimore and the resort and amusement park Tolchester Beach, 30 miles across the bay. *Louise* had a capacity of 2,500 passengers and is estimated to have carried five million people back and forth to Tolchester over a 40-year period. (Maryland Department, Enoch Pratt Free Library.)

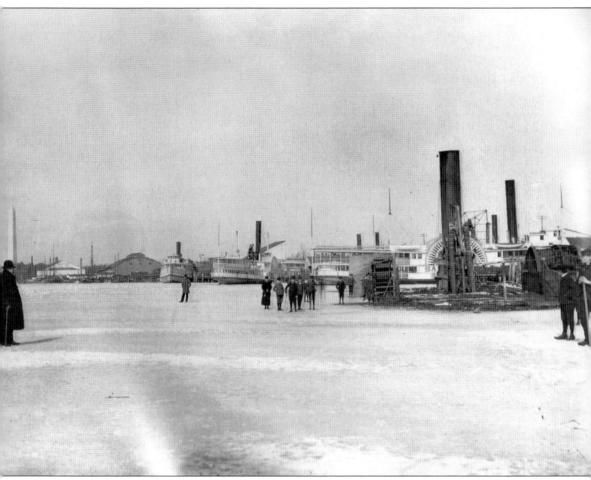

The Washington steamboat wharf at Seventh Street and Maine Avenue in Washington Channel was not a match with Baltimore and Norfolk in terms of activity. Since Washington was neither an industrial city nor a seaport, not a lot of freight moved through the wharf on the Potomac, but passenger traffic between the nation's capital and the military port of Hampton Roads was extensive. Of the steamers based in Washington, the *Lady of the Lake* was a popular traveler to Norfolk with three round trips each week at $2.50 each way, but she was destroyed by fire on February 15, 1895. Spectators of the damage were able to get close by foot on the frozen Potomac. Other boats in the picture include the *Samuel J. Pentz*, built in 1866 for original service in Long Island Sound, and the *T. V. Arrowsmith*, built in 1860 for service between New York and New Jersey. (Calvert Marine Museum.)

A view of part of Norfolk Harbor from the Atlantic Hotel in 1892 shows a mix of hardworking boats, barges, and railroads. The Norfolk and Western Railway (N&W) had its origins in the City Point (Virginia) Railroad and developed dramatically in the Civil War. It connected the Atlantic Ocean and Chesapeake Bay with the West Virginia coalfields and the inland towns of the Deep South. (Kirn Library, Sargeant Memorial Room.)

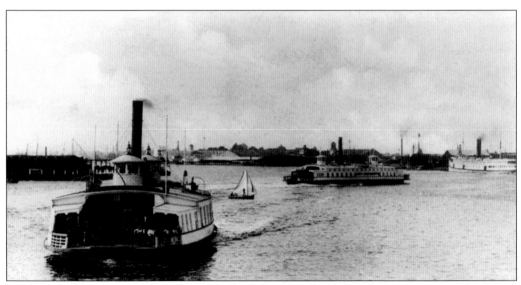

In 1892, the bay steamers shared the Elizabeth River with the ferryboats that passed back and forth between Norfolk and Portsmouth. The ferries first ran in 1636 and would continue in service until 1955, three years after the opening of a tunnel between the two cities in 1952. Smaller, passenger-only ferry service was reinstituted between the two downtown waterfronts 28 years later. (Kirn Library, Sargeant Memorial Room.)

The Baltimore Steam Packet Company would eventually come to be known as the Old Bay Line and stay in business until the end of the steamer era. In 1866, it was scheduling its boats to make important rail connections into the West and Northeast. The *Florida*, depicted in the advertisement, was known as an elegant ship for passengers but a difficult boat for captains to navigate in shallow waters. (Wilson History Room, Portsmouth Public Library.)

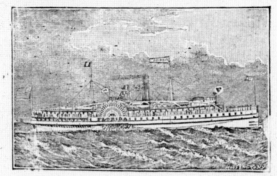

BALTIMORE STEAM PACKET COMPANY

QUICKEST PASSENGER AND FREIGHT ROUTE
BETWEEN THE

NORTH AND SOUTH

Passenger Steamers leave daily, Sundays excepted, from Portsmouth at 5:45 and Norfolk at 6:30 P. M., touching at Old Point. Close connection made at Baltimore with FAST EXPRESS FOR PHILADELPHIA AND NEW YORK, in ample time to connect with all Sound lines of steamers and all lines for Boston and the East. Close connection also made at Baltimore for Washington and the West.

COMING SOUTH { Through Bay Line Express from New York to Baltimore, } **IN FIVE HOURS**

Leaving New York from Desbrosses and Courtlandt Street ferries, trains connect with steamer at Canton. Steamers leave Baltimore from Union Dock at 7 P. M., and from Canton wharf at 8:45 P. M.
For further information, apply to

THE CHESAPEAKE BAY,

ILLUSTRATED.

HAVING seated ourselves, comfortably, on one of the magnificent steamers that daily leave dear old Baltimore to traverse the waters of our noble Chesapeake, we are prepared to inhale the exhilarating breeze, and with interest view the numerous attractions along her historic banks.

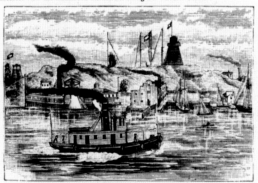

FEDERAL HILL.

As we float swiftly, but noiselessly along, probably the eye of the traveler will first be attracted by a beautiful and lofty bank on the right side of the river known, familiarly, as *Federal Hill*. Memory recalls the glorious, happy event, that not only illustrated American ingenuity, but gave an immortal name to one of Baltimore's most prominent land-marks. In July, 1788, in honor of the ratification of the Constitution, a grand procession of merchants,

In 1879, *The Chesapeake Illustrated* was published by A. Partlett Lloyd, Baltimore. It was a popular guide to the steamer routes south to Norfolk. The text refers to the naming of Federal Hill after a march from Fells Point to the hill by thousands of Baltimore citizens on the occasion of the Maryland General Assembly's ratification of the U.S. Constitution. (Library of Congress.)

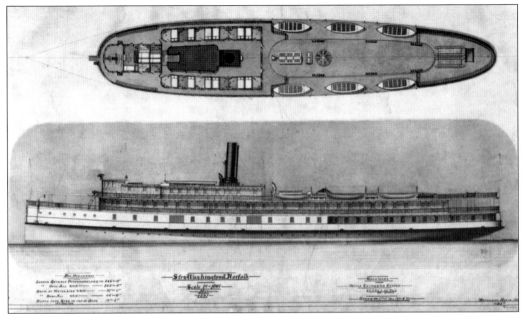

Drawings of the identical steamers *Washington* and *Norfolk* of the Norfolk and Washington Steamboat Company show the design of a typical steamer in 1891. Triple expansion engines, in which common steam from the boiler was run successively through three cylinders, could run drive shafts and propellers and eliminate the need for paddle wheels attached to the side lever engines of earlier boats. (Kirn Library, Sargeant Memorial Room.)

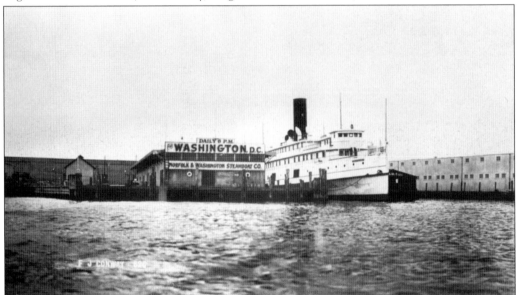

A Norfolk and Washington boat rests at its Norfolk pier in this undated image. The company dated to 1890 and, along with a number of other companies, carried large numbers of passengers between Norfolk and the nation's capital. Traffic was not as heavy as it was between Norfolk and Baltimore, but at various times of the year, it was heavily used by travelers between Florida and the Northeast. A 6 p.m. departure from Norfolk would arrive in Washington 12 hours later. (Kirn Library, Sargeant Memorial Room.)

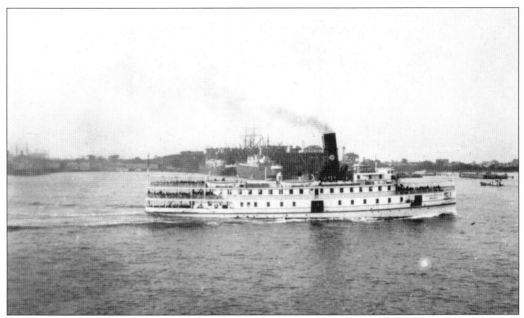

In the lower Chesapeake Bay, steamers were used by railroads to connect train passengers from Newport News and the tip of the Delmarva Peninsula to the cities of Norfolk and Portsmouth. There they could continue their travels south and west. The Chesapeake and Ohio Railway (C&O) had run to Newport News since 1881, and its ferry to Norfolk, the *Virginia*, is seen on June 25, 1890. (Wilson History Room, Portsmouth Public Library.)

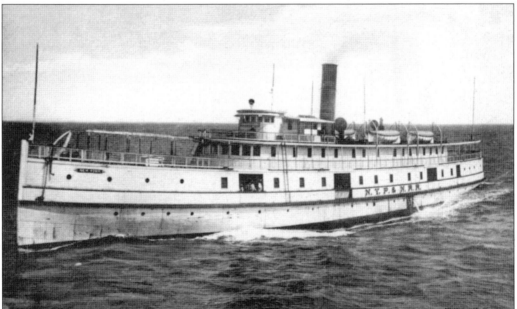

The New York, Philadelphia, and Norfolk Railroad (NYP&N) followed a route down the Delmarva Peninsula to Cape Charles, Virginia, then by barge and ferries to Norfolk and Portsmouth. The *New York*, built in 1888, was the first propeller-driven steamer on the route. She was destroyed by fire in 1910 but was rebuilt and lived the rest of her days as a New York excursion boat until fire took her again at Staten Island in 1932. (Eastern Shore Railway Museum.)

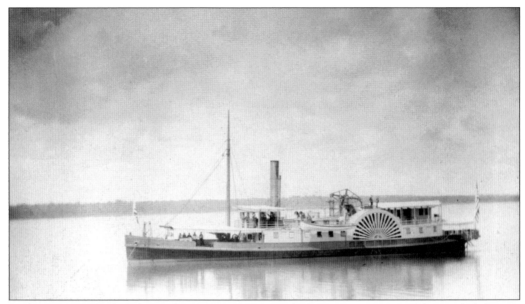

In the 1850s, twelve lighthouse districts were set up in the bay, supporting more than 30 lighthouses along steamer routes. The Coast Guard lighthouse tender *Jessamine*, shown in 1885, supported the engineering needs of Lighthouse District Five and was based in Baltimore. She was decommissioned in 1921 and eventually ended up as a private vessel in Honduras. (Wilson History Room, Portsmouth Public Library.)

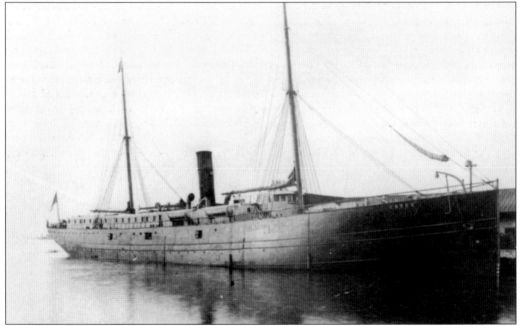

The *Essex*, docked in Norfolk in 1892, was of a different design than most steamers. She was built in 1885 for the Weems Line and limited to 50 first-class passengers. Eventually she ran a route from Norfolk to the Rappahannock River. Her pretensions were lost to history as she was converted to a fishing boat in 1911, a fertilizer carrier in 1912, and a tugboat in 1923. (Kirn Library, Sargeant Memorial Room.)

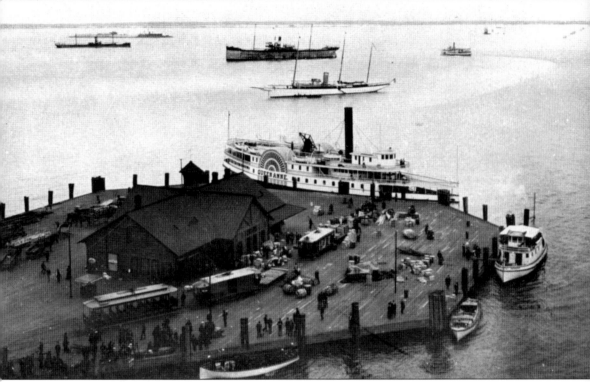

The *Queen Anne* rests at Old Point Comfort in 1907. Built in 1899 by Charles Reeder, she offers a good example of a typical motive power of the 19th century. The Reeder engine was characterized by a double-A frame apparatus on the top deck, sometimes called the boat's steeple, or gallows. The crosshead bar, seated horizontally in the center of the steeple, was attached to two crankshafts, each of which operated the boat's side paddles. Power for the *Queen Anne* came from two boilers operating a steam engine that, even years after its invention, was considered sophisticated, hard-working, and durable. Many that were manufactured in the 1820s were still going strong after the Civil War. A 20th-century passenger of a Reeder-driven boat, Jesse Johnson of the American Philatelic Society, described the sound of the paddles as a steady "click-click-click." And "as each cylinder was activated by steam, the inevitable result was a big 'squoosh' which remained a long time in the memory of those who experienced hearing it." (Casemate Museum.)

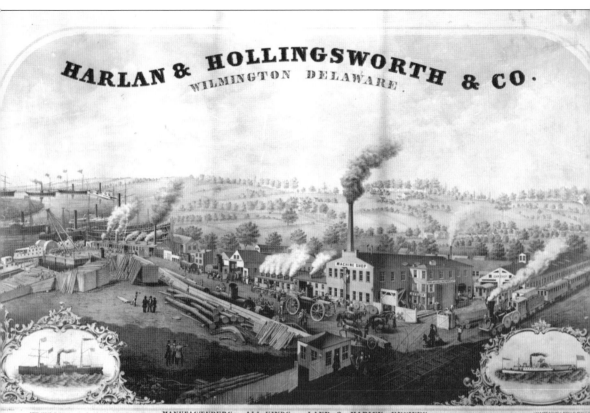

Among the shipbuilding companies that produced the bay steamers, Harlan and Hollingsworth was perhaps the most productive. This undated poster depicting the 76-acre Harlan and Hollingsworth works on the Christina River in Wilmington, Delaware, represents American transportation manufacturing at its best. The company was founded as a machine shop but began manufacturing railroad cars in 1837, and its rail products would eventually show up on tracks as far away as China and Panama. Harlan and Hollingsworth also manufactured fire engines and urban trolleys. Its shipbuilding business made Delaware "the cradle of iron shipbuilding," and included ironclads for the U.S. Navy during the Civil War. In 1904, the company became the Harlan Plant of Bethlehem Shipbuilding, a division of Bethlehem Steel. Between 1840 and 1921, the facility produced approximately 450 boats and ships of various sizes and purposes, many of them pictured in this book. (Library of Congress.)

Two

RIVERS AND OCEANS

An unidentified steamer crosses Breton Bay on the Potomac River near Leonardtown, Maryland. The era of the passenger steamers took place in a body of water that had been formed 12,000 years earlier with the melting of glaciers in the Susquehanna River valley. The headwaters of the Chesapeake Bay reach as far north as Cooperstown, New York, and the bay itself is nearly 200 miles north to south. It is America's largest estuary and the third largest in the world. The bay watershed encompasses 64,000 square miles in parts of six states and includes more than 100,000 streams, creeks, and rivers. Some 150 of those rivers, like the Potomac, are considered navigable, and many of them formed natural inland routes for the bay steamers. (Maryland Department, Enoch Pratt Free Library, courtesy the Maryland Geological Survey.)

<table>
<tr><td colspan="2">

Choptank River Line · ·
═══════════EASTERN SHORE.

</td></tr>
</table>

Steamers leave Pier 4, Light Street Wharf, Baltimore,
daily except Sunday, weather permitting,
for Denton and intermediate
landings, as follows:

Lv. BALTIMORE	6.00 P. M.
" TILGHMAN'S ISLAND	11.00 "
" CORNERS	12.00 "
" OXFORD	12.30 A. M.
" EASTON	2.00 "
" DOUBLE MILLS	3.15 "
" BELLEVUE	3.30 "
" KIRBYS	4.30 "
" CAMBRIDGE	6.00 "
" OYSTER SHELL POINT	6.30 "
" EAST NEW MARKET	7.00 "
" WRIGHTS	7.45 "
" CHOPTANK	8.00 "
" WINDY HILL	8.15 "
" ORANGE	8.45 "
" DOVER BRIDGE	9.00 "
" WILLISTON	10.15 "
" LYFORDS	10.30 "
Ar. DENTON	11.00 "

Returning, leave Denton for Baltimore and intermediate land-
ings, daily, except Saturdays, weather permitting, as follows:

Lv. DENTON	12.00 Noon.
" LYFORDS	12.15 P. M.
" WILLISTON	12.30 "
" DOVER BRIDGE	1.30 "
" ORANGE	1.40 "
" WINDY HILL	2.15 "
" CHOPTANK	2.25 "
" WRIGHTS	3.30 "
" EAST NEW MARKET	3.30 "
" OYSTER SHELL POINT	4.00 "
" CAMBRIDGE	6.00 "
" KIRBYS	6.15 "
" OXFORD	7.00 "
" BELLEVUE	7.10 "
" DOUBLE MILLS	7.30 "
" EASTON	9.30 "
" CORNERS	10.30 "
" TILGHMAN'S ISLAND	11.30 "
Ar. BALTIMORE	5.00 A. M. next morning

Connection at Easton, Oxford, and Cambridge with railroads for
all points.

**For connections with railway lines, round-trip tickets good by steamer
or rail, mileage tickets, &c., see page 5.**

<table>
<tr><td colspan="2">

Wicomico River Line · ·
═══════════EASTERN SHORE.

</td></tr>
</table>

Steamer leaves Baltimore from Pier 3, Light Street
Wharf, for Salisbury and intermediate Landings
every Tuesday, Thursday, and Saturday,
weather permitting, as follows:

Lv. BALTIMORE	5.00 P. M.
" HOOPER'S ISLAND	12.30 A. M.
" WINGATE'S POINT	1.30 "
" DEAL'S ISLAND	3.30 "
" ROARING POINT	4.15 "
" DAMES QUARTER	5.00 "
" MT. VERNON	6.00 "
" WHITE HAVEN	6.20 "
" WIDGEON	6.30 "
" COLLINS	6.45 "
" QUANTICO	7.10 "
Ar. SALISBURY	8.20 "

Returning, leave Salisbury for Baltimore and intermediate land-
ings every Monday, Wednesday, and Friday, weather permitting, as
follows:

Lv. SALISBURY	2.30 P. M.
" QUANTICO	3.15 "
" COLLINS	3.45 "
" WIDGEON	4.00 "
" WHITE HAVEN	4.15 "
" MT. VERNON	4.30 "
" DAMES QUARTER	5.15 "
" ROARING POINT	5.45 "
" DEAL'S ISLAND	7.00 "
" WINGATE'S POINT	9.00 "
" HOOPER'S ISLAND	9.30 "
Ar. BALTIMORE	6.00 A. M. next morning

**For connections with railway lines, round-trip tickets good by steamer
or rail, mileage tickets, &c., see page 5.**

In 1900, the Choptank and Wicomico River Lines ran overnight steamers between Baltimore and the towns of Salisbury and Denton on Maryland's Eastern Shore. Salisbury had been a Colonial river port dating to 1732, and the town became the crossroads of the Delmarva Peninsula, especially with the advent of the steamers. Steamer service to Denton began in 1850 and connected with stagecoaches that ran between Easton, Maryland, and Felton, Delaware. (Maryland Department, Enoch Pratt Free Library.)

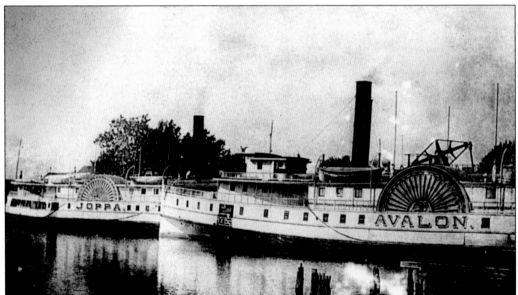

The *Avalon* and *Joppa*, docked on the Choptank River at Denton, Maryland, had been built for the Maryland Steamboat Company in the 1880s. Most of their careers were spent on the rivers and inlets of the bay under various owners. In 1935, *Joppa* was converted to a diesel freighter and later abandoned. In 1937, *Avalon* was converted to a lumber barge between Baltimore and North Carolina and in later years carried summer produce from the Eastern Shore of Virginia to the cities. (Courtesy Robert Lewis.)

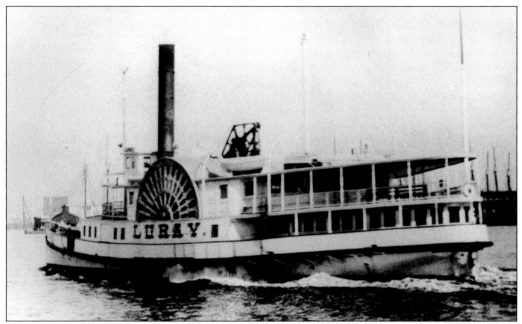

In 1894, the *Luray*, owned by the Old Dominion Line, traveled a route from Norfolk past Jamestown to Richmond by way of the James River. The original Jamestown settlers, under Capt. John Smith, had first identified Richmond as a river city in 1607. The town was not officially mapped until 1737, when it was seen as an inland market for Virginia commerce. (Kirn Library, Sargeant Memorial Room.)

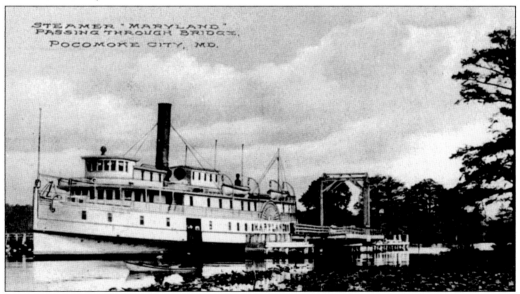

The *Maryland* passes through Cassatt's Bridge at Pocomoke, Maryland, *c.* 1910. Alexander Cassatt had developed the NYP&N Railroad and gone on to become president of the Pennsylvania Railroad (PRR). He was a preeminent engineer who conceived the revolutionary Hudson River rail tubes in Manhattan and Pennsylvania Station on Eighth Avenue. The NYP&N and its moveable bridge at Pocomoke were also considered engineering innovations of the time. (Courtesy Robert Lewis.)

The *Virginia*, stopped at the Onancock, Virginia, wharf around the 1920s, was a sister ship to the *Maryland*, both used by the Baltimore, Chesapeake, and Atlantic Railroad (BC&A). The two boats had difficult histories. *Maryland* burned to the water in 1915 and was eventually rebuilt as a sailing barge. *Virginia* was considered too slow and expensive to operate and was eventually converted to a freight barge in 1937. (Cape Charles Historical Society.)

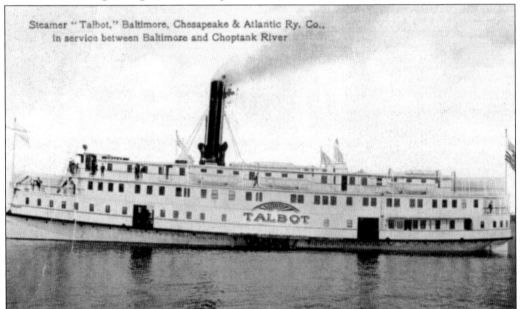

The *Talbot*, also a BC&A steamer, was built in 1912 to replace *Avalon* and *Joppa* on the route from Baltimore to the Choptank River and later ran on the Potomac River route. She ended her years as *The City of New York*, operating between Manhattan and the resort and amusement area of Keansburg, New Jersey. The boat was driven ashore in a heavy gale and scrapped in 1950. (Maryland Department, Enoch Pratt Free Library.)

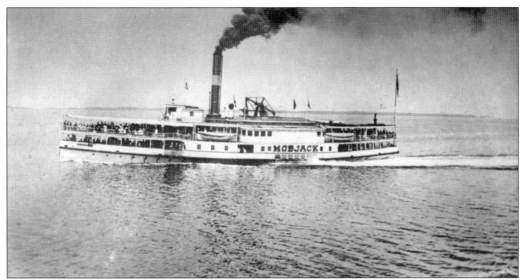

The sidewheel steamer *Mobjack*, seen in 1912, was a very popular boat used for pleasure by vacationers and for commerce by watermen and farmers in the shallow waters and inlets of the lower Chesapeake Bay. The *Mobjack*, and its owners, the Old Dominion Steamship Company, were participants in an important U.S. Supreme Court case in 1905 that determined that vessels involved in interstate commerce could be taxed by the states whose shores they touched. (Wilson History Room, Portsmouth Public Library.)

Passengers approach the *Potomac* at Port Royal, on Virginia's Rappahannock River, in 1933. Built in 1894 for the Weems Line, *Potomac* was one of the most beloved and durable of the bay steamers. She plied between Baltimore and Washington until 1910 before moving to the Rappahannock. One hundred seventy-seven feet long and known as fast, steady, and comfortable, her last years as a passenger boat were spent in the lower bay until 1933. (Mariners' Museum.)

A typical wharf on the Rappahannock River, *c.* 1920s, extended out into deeper waters and was prepared to exchange both passengers and freight with boats between Norfolk or Baltimore and Fredericksburg, Virginia. The Rappahannock is an important river in American history. It supported some of the first settlements of the Virginia colony in the 1600s and was considered a barrier between North and South in the Civil War, thus the site of many battles. At the height of river commerce, there were 36 landings along the Rappahannock, and many could handle five vessels at once. They sent grain, cattle, and other agriculture to Baltimore and received hard goods for the merchants of the small towns along the 80 miles of river from the bay to Fredericksburg. Steamer stops were scheduled at larger wharves and were flagged as needed at smaller locations. Wharf areas, with their long piers and sheltered harbors, were also popular for swimming and fishing. (Essex County Museum and Historical Society.)

Saunders Wharf was Stop 27 on the Rappahannock River. Built in the early 1800s, it was one of the most active of the wharves through 1948. For many steamer passengers, as for these pictured c. 1910, travel was a dress-up affair and associated with the smiling faces of comings and goings. The wharf's passenger waiting room is shown in a restoration photographed in 1990. Much of the passenger travel on the Rappahannock was on steamers that plied overnight from Baltimore, taking the following day and night to reach Fredericksburg. In the 1930s, the fare was $7.50, including five meals in a linen and silverware dining room and two nights in a stateroom. (Essex County Museum and Historical Society.)

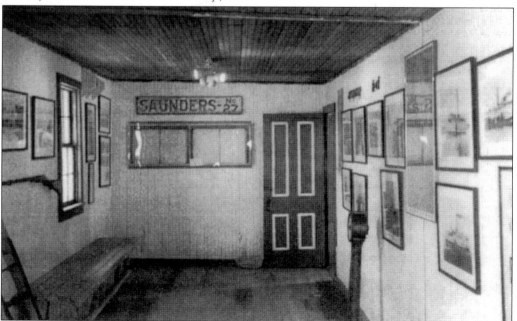

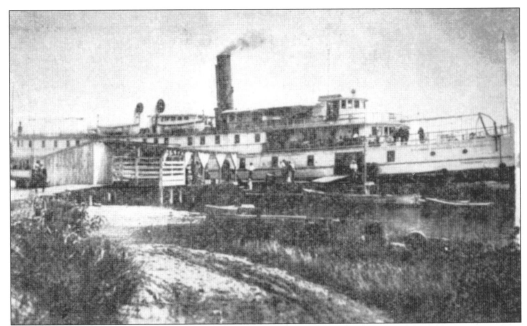

The inland waters of coastal North Carolina lay just south of Norfolk and the Chesapeake Bay. The *Neuse*, named after the river that leads to New Bern, began operation by the Norfolk Southern Railway in 1890. In 1908, she was renamed after Virginia's Piankatank River and operated by the BC&A as the largest boat to operate between Baltimore and the shallow waters of Virginia's Eastern Shore. (Mariners' Museum.)

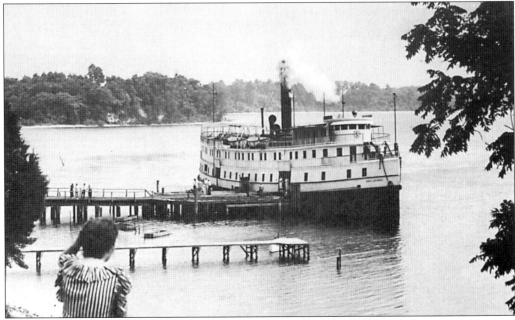

The *Anne Arundel* of the Weems Line rounds the bend of the St. Mary's River at St. Mary's, Maryland, in 1934. St. Mary's was Maryland's first settlement and its capital until 1695. The *Anne Arundel* was considered to be a graceful, comfortable, and seaworthy craft, but she had been equipped with a tugboat engine that did not always serve her well. (Mariners' Museum.)

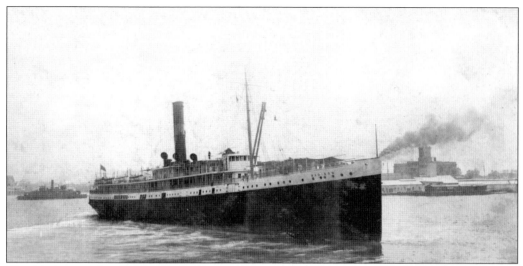

The *Madison* of the Old Dominion Line is seen in Norfolk Harbor on September 9, 1915. The *Madison* was one of a number of passenger ships that sailed out of the bay to other coastal cities and as far away as Europe. The Old Dominion Line was a post–Civil War version of the New York and Virginia Steamship Company that sailed between Norfolk and New York City and dated back to 1850. (Wilson History Room, Portsmouth Public Library.)

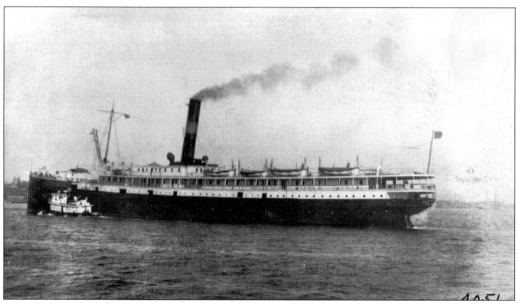

The Old Dominion *Princess Anne* leaves Portsmouth February 15, 1916. On another February day in 1930, the 350-foot ship grounded on the Rockaway Shoals outside New York harbor. The 32 passengers and 74 crew members were eventually rescued, and nine days later, the ship began to break up under pounding seas. She is now believed to have been ultimately buried by the waves beneath Rockaway Beach. (Wilson History Room, Portsmouth Public Library.)

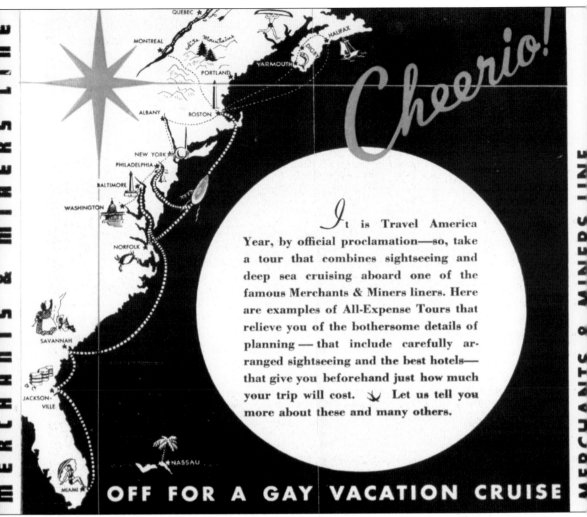

It is Travel America Year, by official proclamation—so, take a tour that combines sightseeing and deep sea cruising aboard one of the famous Merchants & Miners liners. Here are examples of All-Expense Tours that relieve you of the bothersome details of planning — that include carefully arranged sightseeing and the best hotels— that give you beforehand just how much your trip will cost. Let us tell you more about these and many others.

OFF FOR A GAY VACATION CRUISE

Merchant and Miners Transportation Company first operated wooden-hulled sidewheelers between Baltimore and Boston in 1852. The company entered the cotton trade with ships between New York and Savannah in 1876 and began an expansion that would include Norfolk, Newport News, Miami, and Nassau. Havana was on the route for a brief time in 1920. "Travel America Year" (TAY) was 1940, by proclamation of the federal government. A publication of the Richmond, Virginia, economic development office of June 1940 noted that TAY predicted comparatively good times that lay ahead for America: "While nearly a score of nations suffer the fearsome agonies of war, the United States is faced at home with the prospect of a gigantic pincer movement executed by our own recreational travelers. The most hardened ingrate surely must count such a blessing." (Maryland Department, Enoch Pratt Free Library.)

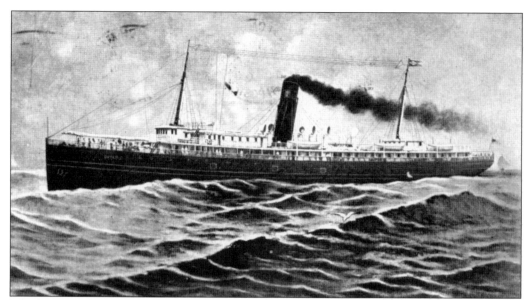

Merchants and Miners ships were among the first to be equipped with radio under the Wireless Ship Act of 1910. On April 9, 1912, fire broke out in a hold of *Ontario* in heavy seas. "In the meantime," according to unattributed reporting, "Ingalls, the wireless lad, was sending out the SOS signals for help. His little wireless hut on the deck was almost directly over the burning part of the ship, and life within it was almost unbearable. But that had no effect on Ingalls." The ship survived. (Maryland Department, Enoch Pratt Free Library.)

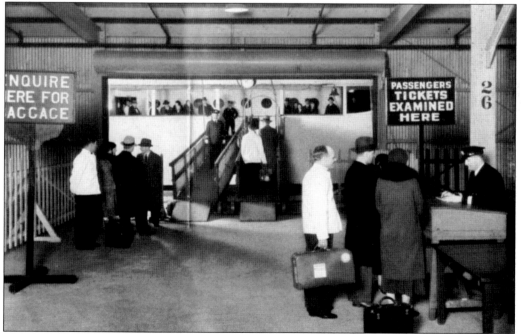

A Merchants and Miners brochure shows the simple procedure for Baltimore check-in to its cruises in the 1930s. It was important to show that dock areas, though spartan and industrial, were clean and orderly, and that white-coated porters stood ready at the gangplank to offer service. (Maryland Department, Enoch Pratt Free Library.)

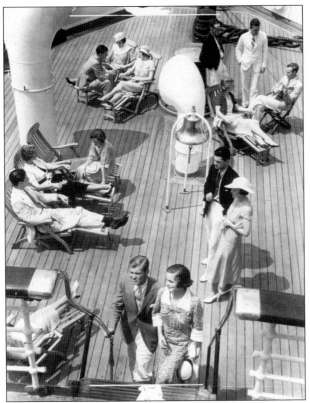

Passengers relax and visit on the promenade deck of a Merchants and Miners ship, at left, that might have been the *Dorchester* as pictured on a postcard, below. A company brochure described *Dorchester*: "The cabin accommodations are designed for the luxurious comfort of the Florida traveling public. In keeping with the modern trend of shipbuilding, the accommodations are complete in every detail, as found in the finest hotel." *Dorchester* had a capacity of 314 passengers and featured telephones and electric fans in each room. Florida-bound passengers could bring along automobiles for an extra charge. In 1942, *Dorchester* was converted to a troop ship of the U.S. Army, doubling her capacity to 906 crew and passengers. She was sunk by German submarines off Greenland on February 3, 1943. (Maryland Department, Enoch Pratt Free Library.)

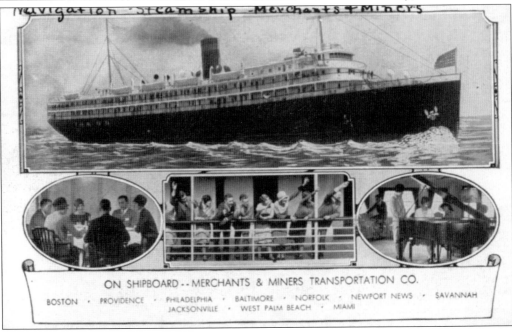

Navigation · Steamship · Merchants + Miners

ON SHIPBOARD -- MERCHANTS & MINERS TRANSPORTATION CO.

BOSTON · PROVIDENCE · PHILADELPHIA · BALTIMORE · NORFOLK · NEWPORT NEWS · SAVANNAH
JACKSONVILLE · WEST PALM BEACH · MIAMI

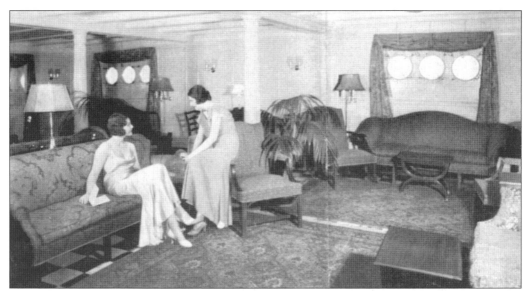

Passengers relax in a lounge of the *City of Baltimore* en route to Europe. The Baltimore Mail Steamship Company carried mail and passengers between the United States, France, and Germany using five ships capable of 16 knots' speed. Each ship accommodated 81 passengers in rooms with private baths at fares of $90 one-way and $171 round-trip to Hamburg. (Maryland Department, Enoch Pratt Free Library.)

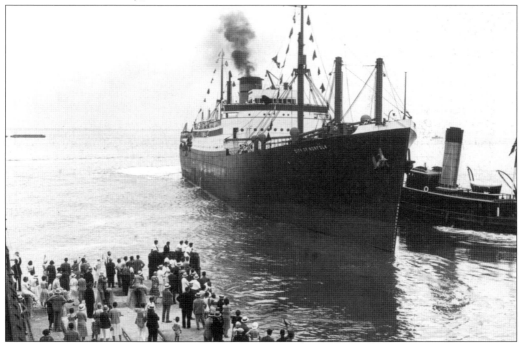

The *City of Norfolk* was another of the Baltimore Mail Steamship liners, seen arriving for a ceremony in its namesake city probably in the 1930s. Built in 1918 by Bethlehem Steel at Alameda, California, she was lengthened and renamed *City of Norfolk* in 1930. In 1938, she was sold to the Panama-Pacific Line for sailings between New York and California through the Panama Canal. (Kirn Library, Sargeant Memorial Room.)

The *Robert E. Lee*, shown in Norfolk harbor, ran under the flag of the Eastern Steamship Lines as one of eight ships operating scheduled service from Norfolk to St. John, New Brunswick, and stops in between. Another conscript for World War II after 1941, she was sunk by German submarines offshore of the Mississippi Delta. (Wilson History Room, Portsmouth Public Library.)

The *George Washington*, seen here over the rooftops of Olde Town Portsmouth on January 29, 1927, was a vessel of the Eastern Steamship Lines that operated up and down the East Coast from Nova Scotia to Havana. She was taken by the U.S. Army in World War II, sold to the French government, renamed the *Gascogne*, and used in the Battle of Dunkirk. (Wilson History Room, Portsmouth Public Library.)

Three

OLD POINT COMFORT

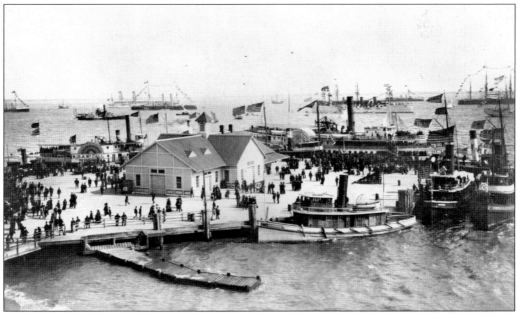

The wharf at Old Point Comfort in Hampton, Virginia, seen here during the International Naval Review of 1893, was a touchstone of steamer travel on the bay. The battleships in the bay have come from navies all over the world. Two of the boats at the wharf are identifiable and notable. The North Carolina steamer *S. A. McCall* (left) was described in the Windsor, North Carolina, *Public Ledger* of April 25, 1988, as "Swift and elegant. When her head gets pointed down the stream she just leaves one place and reaches the other at the same moment." The tug *Britannia*, second from the right, served as a character in a portion of the 1914 Jack London novel *Mutiny of the Elsinore*, in which she pulls a great sailing ship down the bay: "Britannia towed us well into the afternoon and did not cast us off until the ocean was wide about us and the land a faint blur on the western horizon. Here, at the moment of leaving the tug, we made our 'departure'—that is to say, technically began the voyage, despite the fact that we had already traveled a full twenty-four hours away from Baltimore." (Hampton History Museum.)

The town of Hampton, shown above during the Civil War, lies to the northwest, and the Old Point wharf is seen at the right in this 1880 painting of Fort Monroe, shown below. Just as the War of 1812 had energized the Baltimore harbor that lay beneath Fort McHenry at the northern reach of the bay, it had caused the redevelopment of Fort Monroe at the southern entrance to the bay in Hampton Roads. It was the only American fort completely surrounded by a moat, and it stands into the 21st century as the longest continually fortified place in the United States, dating back to 1609. Dubbed the "Gibraltar of Chesapeake Bay" and named after Pres. James Monroe, its current version was constructed in 1834 with the guidance of a young army engineer, Robert E. Lee. The wharf was sometimes called Government Wharf, but the English colonists had first named it Point Comfort, perhaps because it lay at the end of the long journey across the Atlantic and 30 miles southeast of Jamestown. (Above: Library of Congress; Below: Kirn Library, Sargeant Memorial Room.)

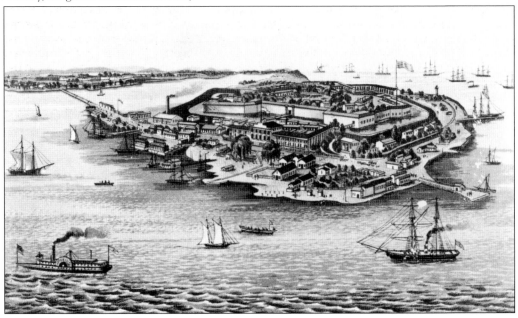

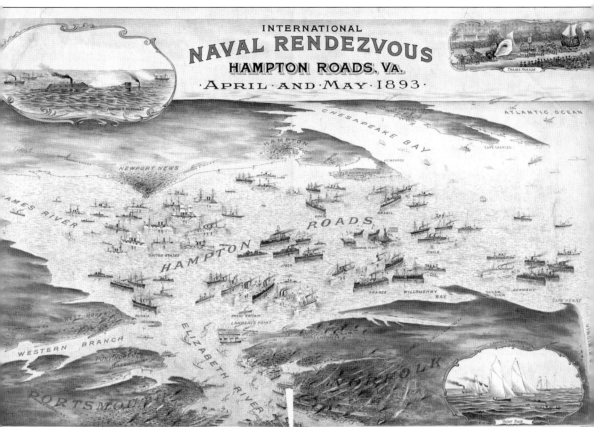

INTERNATIONAL NAVAL RENDEZVOUS
HAMPTON ROADS, VA.
·APRIL·AND·MAY·1893·

·EXCURSION·RATES·ON·ALL·RAILROADS·AND·STEAMSHIP·LINES·

Norfolk was, and remains into the 21st century, the world's largest naval base, and Hampton Roads one of the world's largest natural harbors. The Naval Rendezvous of 1893 took place in the area of highest traffic for the bay steamers, with Old Point Comfort at its center and its chief vantage point. The rendezvous was encouraged by an act of Congress as a precursor to the World's Fair of that year, the Chicago Columbian Exhibition. It brought together 38 warships of 10 countries, their respective anchorages mapped in a poster that also noted the area as the location of the great Civil War battle between the *Monitor* and the *Merrimac* (CSS *Virginia*). Two years before Marconi would invent wireless transmission, reporters marveled at communication between the ships by way of flags and pennants, a constant noise of signal guns and whistles, and the experimental use of carrier pigeons. (Library of Congress.)

43

Old Point and its regal hotel, the Chamberlin, are seen north across the bay from the Norfolk shore. If the poster on the previous page was correct in its setting of anchorages, the ships in view might be those of Germany, Chile, or Brazil. Not all of the navies depicted in the poster were actually in attendance. Three ships of the Russian navy, for example, had been held up by ice in the Baltic Sea. (Hampton History Museum.)

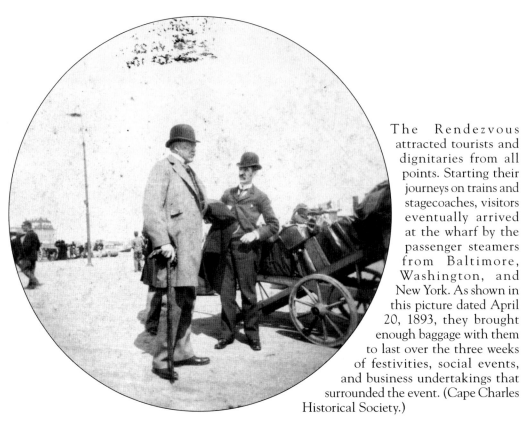

The Rendezvous attracted tourists and dignitaries from all points. Starting their journeys on trains and stagecoaches, visitors eventually arrived at the wharf by the passenger steamers from Baltimore, Washington, and New York. As shown in this picture dated April 20, 1893, they brought enough baggage with them to last over the three weeks of festivities, social events, and business undertakings that surrounded the event. (Cape Charles Historical Society.)

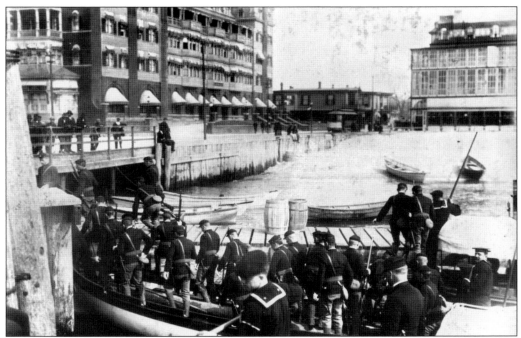

The Old Point Comfort wharf area was constantly busy with both commercial and military activity. For military boats in Hampton Roads harbor, often the best method of moving personnel back and forth from land to sea was by smaller boats, as in this marine landing against the backdrop of the Chamberlin Hotel in 1896. (Casemate Museum.)

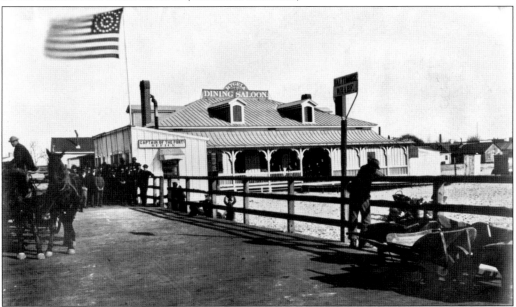

The port captain's office and the Hygeia Dining Saloon are seen in 1864. The saloon was associated with the Hygeia Hotel, which had been named after the Greek goddess of health. Of the hotel, the *Norfolk and Portsmouth Herald* of May 29, 1822, said, "It offers to the invalid, the tourist, the man of leisure, every convenience which the humor of the one, and the fashionable tone of the other may exact." During the Civil War, it was converted to use as a hospital. (Casemate Museum.)

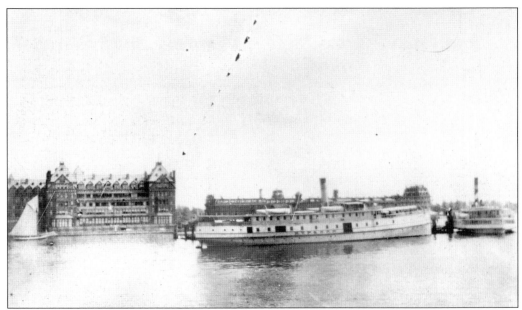

A steamer of the NYP&N blocks a view of the Hygeia Hotel. Edgar Allan Poe, who had served in the army at Fort Monroe under the name Edgar A. Perry, had famously recited poetry on the front portico in 1849. Post–Civil War, it provided services to 1,000 guests with healing baths of various sorts, gaslights, hydraulic elevators, and bathrooms on every floor. Construction of its neighbor, the Chamberlin, was begun in 1887, and eventually Chamberlin interests bought the Hygeia and tore it down. (Wilson History Room, Portsmouth Public Library.)

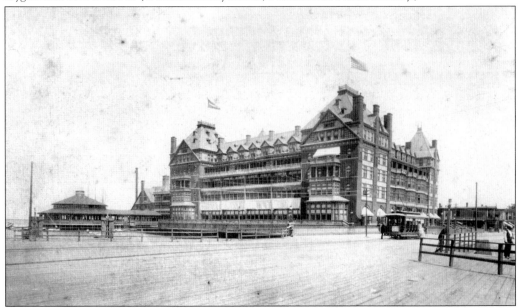

The original Chamberlin Hotel, pictured in 1901, was the creation of John Chamberlin, a restaurant and gaming magnate of the day. It was designed by the same architects who had created the Library of Congress. It featured the latest conveniences, including its own ice and electrical plants, a bowling alley, and a 1,000-square-foot ballroom. Its dining room supported a full dinner orchestra and large picture windows on the bay. (Hampton History Museum.)

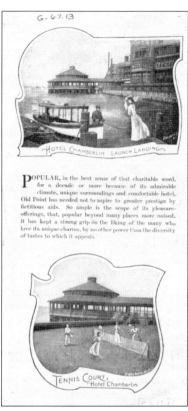

G. 67.13

HOTEL CHAMBERLIN LAUNCH LANDING

POPULAR, in the best sense of that charitable word, for a decade or more because of its admirable climate, unique surroundings and comfortable hotel, Old Point has needed not to aspire to greater prestige by fictitious aids. So ample is the scope of its pleasure-offerings, that, popular beyond many places more noised, it has kept a strong grip on the liking of the many who love its unique charms, by no other power than the diversity of tastes to which it appeals.

TENNIS COURT, Hotel Chamberlin.

The hotel and wharf area were places of two worlds, that of the water-borne traveler and that of those who lived and worked on the land. The trolleys and carriages connected the flowing water with one of America's oldest cities. By the time of these pictures, Hampton, Virginia, was already 300 years beyond its origins. Its St. John's Episcopal parish was founded in 1610, making it the oldest in the country. The first free American public schools had been opened in the city, and what is now Hampton University offered the first free education to freed slaves. The city was burned to the ground in the Civil War and revitalized in part by the continuing commerce of the bay steamers. (Hampton History Museum.)

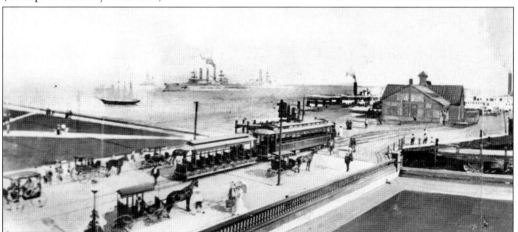

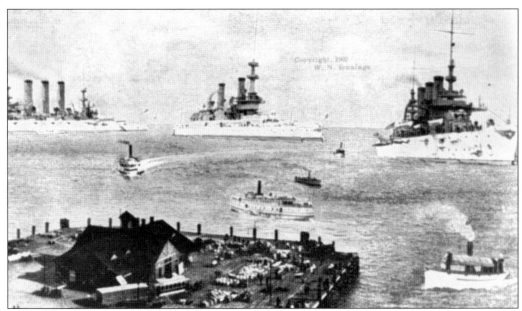

On December 16, 1907 (above), and February 22, 1909 (below), crowds on Old Point watched the departure and return, respectively, of what came to be called the Great White Fleet. The fleet consisted of 16 new battleships, painted white and assembled by order of Pres. Teddy Roosevelt with the purpose of demonstrating American naval power to the rest of the world. The president himself watched from his yacht *Mayflower* as history's first fleet of steam-powered, steel battleships headed out to the Atlantic. It included auxiliary ships, involved 14,000 sailors, and was accompanied by various other flotillas along the way. The Great White Fleet made 20 port calls on six continents and traveled 43,000 miles around the world. The postcard view of its departure was an obviously manufactured image. The return of the fleet in heavy rain was visited by the popular steamer *Mobjack* and the *Annie L. Vansciver*, which traveled mostly between Elizabeth City and Currituck, North Carolina. The steamer was eventually drafted into military service during World War I. (Above: Casemate Museum; Below: Library of Congress.)

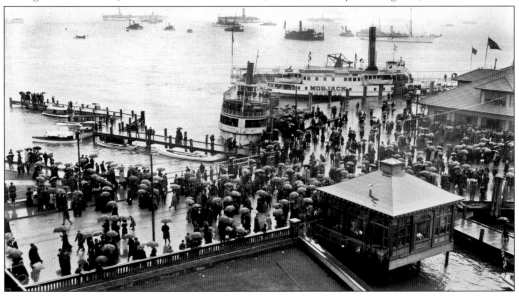

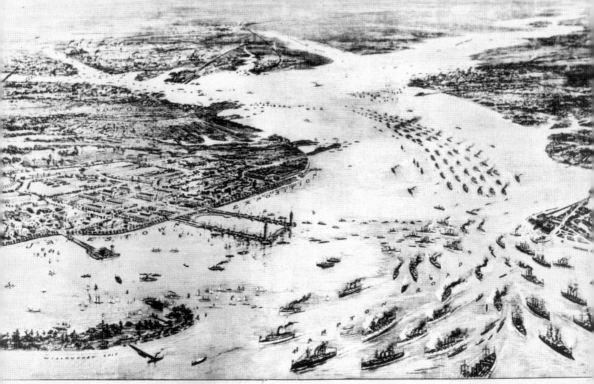

JAMESTOWN TER-CENTENNIAL EXPOSITION
HISTORICAL - EDUCATIONAL - NAVAL - MILITARY - INDUSTRIAL
Commemorating the 300th Anniversary of the First Permanent English Settlement in America.
Located on Hampton Roads, close to Norfolk, Portsmouth, Newport News, Hampton, and Fortress Monroe.

NS APRIL 26. 1907. GENERAL OFFICES: **NORFOLK, VIRGINIA.** CLOSES NOV. 30. 190

Norfolk and Western Railway

The departure of the Great White Fleet in 1907 had been a central event of the Jamestown Exposition, a tercentennial celebration of the founding of Jamestown by the colonists in 1607. The poster looks west into Hampton Roads Harbor at the Elizabeth, Nansemond, and James Rivers, shown from left to right. The exposition was held at Sewell's Point, then a rural area on the bay that was roughly equidistant from the centers of Norfolk, Portsmouth, Newport News, and Hampton. It included separately housed exhibitions of 21 American states, a display of a section of the Hudson River tube that would later be set between New Jersey and New York, and a re-creation of the Civil War battle between the *Monitor* and the *Merrimac*. By the time it was over, three million people had attended, many by way of the bay steamers. Ten years later, the site of the exposition began conversion into what would become the Norfolk Naval Base, incorporating exposition buildings that remained in use into the 21st century. (Kirn Library, Sargeant Memorial Room.)

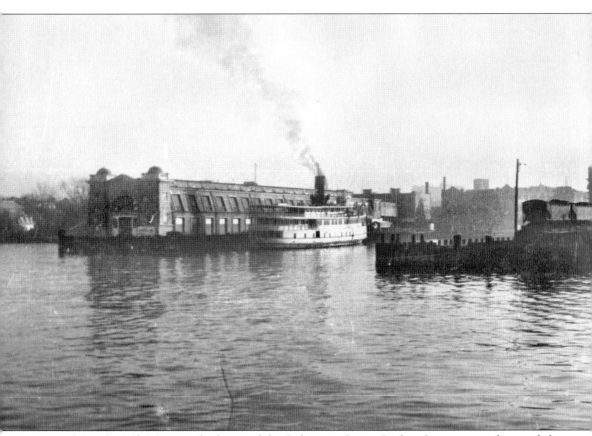

In the early 20th century, the boats of the Baltimore Steam Packet Company, nicknamed the Old Bay Line, had practically worn in their own channels on the basic route between Baltimore and Norfolk. They moved in and out of the harbors with ease and settled comfortably at their assigned piers. But the beginning of the century may have been the beginning of the end for the steamers. This undated picture shows an Old Bay Line steamer, always fired up and ready to go, pausing between journeys at Norfolk's Boush Street Pier on the Elizabeth River. Boush Street was named after Norfolk's first mayor in 1736, Col. Samuel Boush. The end of the pier is believed to have been the site of the city's first "witch ducking" under Colonial law in 1716. The pier and warehouse were converted into a luxury condominium complex in the late 1980s, long after the steamers had disappeared. (Kirn Library, Sargeant Memorial Room.)

Four

BOATS AND TRAINS

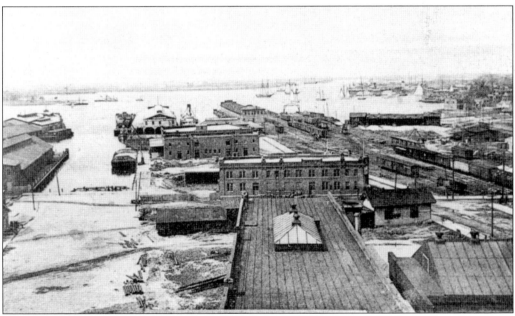

Norfolk harbor at the turn of the century demonstrated the transition that would propel steamers into the last half of their lifetime on the bay. The serenity of the Boush Street pier (top center) is surrounded by engines of change. In 1884, the NYP&N opened its ferry and barge service between the end of track from New York at Cape Charles and the continuation of track into the South behind the Norfolk pier. The steamer to the left of the pier ferried train passengers back and forth from Norfolk to Cape Charles. The NYP&N was very successful, and its creator, Alexander Cassatt, went on to become president of the Pennsylvania Railroad. At the same time, the many steamboat lines of the Chesapeake Bay had been faltering, and as they sputtered, they were bought up by the PRR and other railroads, some of which were in turn folded into the Pennsylvania system. The prosperity of the steamers under the concentrated ownership of the railroads made a great start on the century, especially before the coming years of the automobile. (Cape Charles Historical Society.)

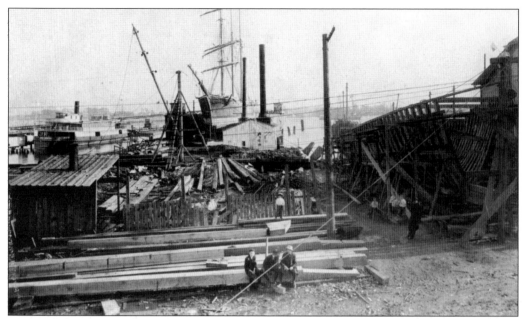

A shipyard in Norfolk harbor attends to wooden-hulled ships in 1910. The three-masted schooner on the water was typical of sailing freighters on the bay. Ships as large as this one entered bay commerce beginning in the 1840s and gradually disappeared after the first quarter of the 20th century. The steamer docked at the left is the *Annie L. Vansciver*. (Kirn Library, Sargeant Memorial Room.)

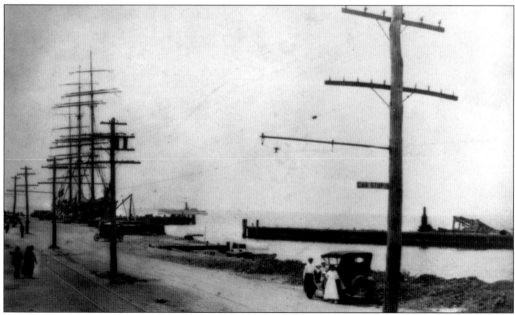

A distant James River steamer passes the boat harbor at the foot of Jefferson Avenue in Newport News, c. 1915. Not shown in this picture is a small airport at the left of the trolley tracks. In 1881, Newport News had become the Atlantic deepwater terminus of the Chesapeake and Ohio Railroad, and in 1886, the Newport News Shipbuilding and Drydock Company opened for business. It would go on to build many of the bay steamers. (Hampton History Museum.)

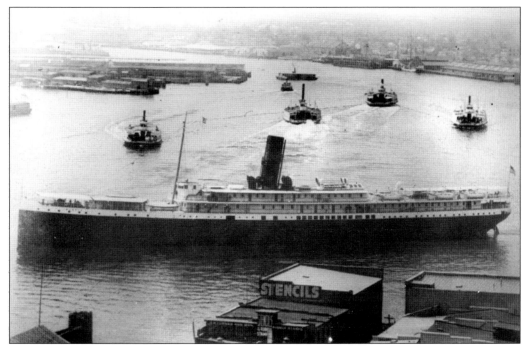

The Old Dominion Steamship Line's *Monroe* passes between Norfolk and the Portsmouth waterfront in 1914. The ferryboats on the right are headed in the direction of the harbor facilities of the Seaboard Air Line Railroad, whose slogan was "Through the Heart of the South." In the consolidation of rail and steamer lines of the time, the Seaboard absorbed the Baltimore Steam Packet Company/Old Bay Line. (Kirn Library, Sargeant Memorial Room.)

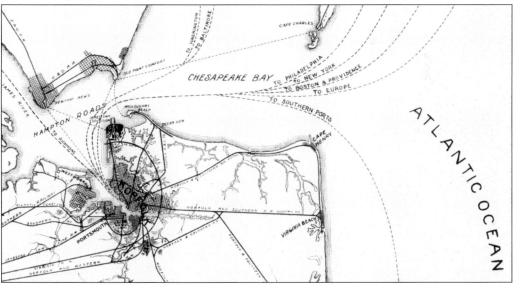

This map from the *Old Bay Line* magazine of October 1910 shows all of the steamer and railroad routes that converged in Hampton Roads at the time. The region was one of the most active transportation hubs in the United States and the most important meeting place of commerce, freight, and travelers between the American North and South. (Kirn Library, Sargeant Memorial Room.)

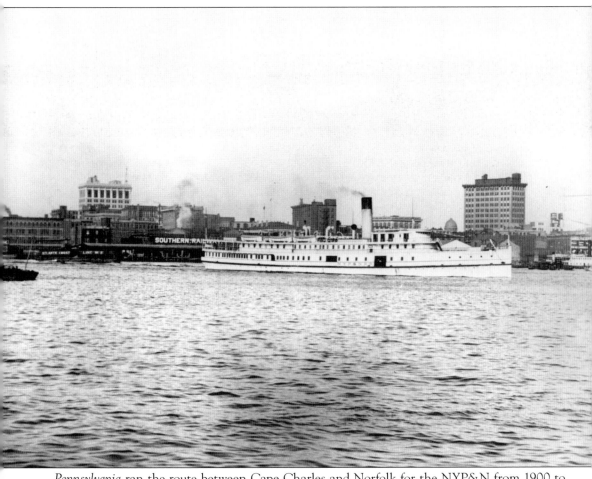

Pennsylvania ran the route between Cape Charles and Norfolk for the NYP&N from 1900 to 1928. With twin four-cylinder engines capable of 3,300 horsepower, she was reputed to be the fastest ship on the bay at the beginning of the century. Passing the Norfolk waterfront, her top decks had a view of the domed city hall several blocks from the water. Upon the death of Gen. Douglas MacArthur in 1964, the building became his burial place and memorial. In the 21st century, its museum and library remain an international source of military history and research. (Kirn Library, Sargeant Memorial Room.)

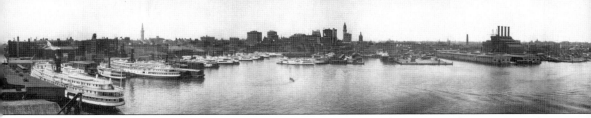

Much of the city of Baltimore was new construction in 1905. The Great Baltimore Fire of February 7, 1904, had taken just 30 hours to destroy 1,500 buildings. Declared Mayor Robert McClane: "To suppose that the spirit of our people will not rise to the occasion is to suppose that our people are not genuine Americans. We shall make the fire of 1904 a landmark not of decline but of progress." McClane committed suicide four months later, but the city and its port came back stronger and the *Baltimore-American* editorialized that "One of the great disasters of modern time had been converted into a blessing." Some identify 1905 as the peak year of the bay steamers. Fifty-two of them were home-ported in Baltimore, half of the bay fleet. The Light Street piers could accommodate only a third of them at one time, and scheduling had to be precise. (Library of Congress.)

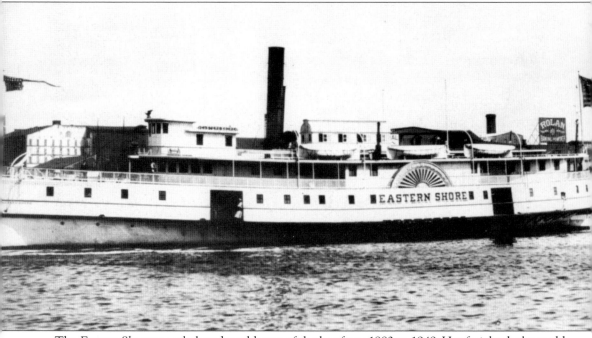

The *Eastern Shore* was a beloved workhorse of the bay from 1883 to 1949. Her freight decks could accommodate 3,500 barrels at one time of the Irish potatoes that were a staple export of the Delmarva Peninsula, and she carried passengers in numerous, though spartan, sleeping chambers. Her last years were spent after World War II on the Intracoastal Waterway from Baltimore to Norfolk and Savannah, Georgia. (Eastern Shore of Virginia Historical Society.)

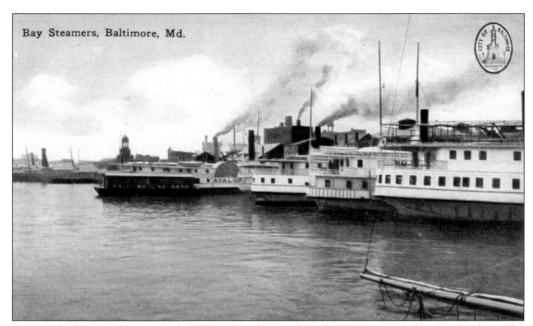

Steamers of various shapes and sizes are lined up and ready to move in Baltimore Harbor. The sidewheel steamer *Avalon* is seen at the urban end of its route between Baltimore and the rural Choptank River ports across the bay and 60 miles to the southeast. (Maryland Department, Enoch Pratt Free Library.)

Love Point was a destination at the northern tip of Kent Island, due east of Annapolis and the largest island in the Chesapeake Bay. The Baltimore and Eastern Railroad, a subsidiary of the Pennsylvania Railroad, continued service across a railroad bridge to the mainland in the direction of Delaware, then down Delmarva to Salisbury, Maryland. (Maryland Department, Enoch Pratt Free Library.)

BALTIMORE AND EASTERN RAILROAD COMPANY

Corrected to January 31, 1932 "EASTERN STANDARD TIME"

SCHEDULE OF
STEAMER PHILADELPHIA
BETWEEN
Baltimore, Md. and Love Point, Md.
IN EFFECT NOVEMBER 14th, 1931

57

The Merchants and Miners steamer *Allegheny* is docked in Baltimore Harbor on a February day in 1936. The 150-mile journey between the top and bottom of the bay could travel through two seemingly different worlds of weather in the winter months, from harsh to relatively mild. In an indication of how important the steamers were to the bay community, Norfolk's *America Beacon* reported on January 1, 1820: "We are very much disappointed in the *Virginia's* not arriving here yesterday at the appointed hour, as it deprived us of our usual budget of the news in anticipation of the mail. From her not getting in during the subsequent portion of the day, we feel apprehension that she is frozen up in Baltimore." Among the worst weather disasters to befall a steamer was the hurricane of October 23, 1878. Originating as a tropical storm in Jamaica five days earlier, it came across North Carolina with 100-mile-per-hour winds and lifted the steamer *Express* out of the mouth of the Potomac River. The boat and 18 of 31 passengers and crew were lost. (Maryland Department, Enoch Pratt Free Library.)

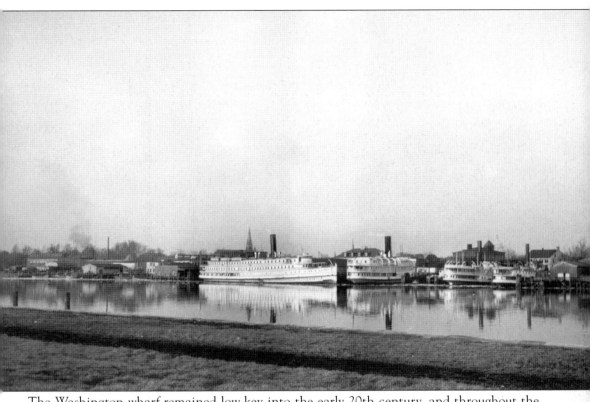

The Washington wharf remained low-key into the early 20th century, and throughout the steamer era, U.S. presidents and other notables rode them to important events in Hampton Roads, especially to Old Point Comfort. Train travelers made steamboat connections that might otherwise have been made in Baltimore. The two prominent steamers (center) in this undated picture are the *Midland* and *Southland*. Both operated for the Norfolk and Washington Steamboat Line. *Southland* traveled between Washington, Alexandria, Old Point Comfort, and Norfolk. She was a relatively small steamer, and after World War II service with the 12th Fleet in Europe, she was deemed probably not able to make the return trip across the Atlantic. She was sold to a Chinese company and operated as the *Hung Yung* until 1955. Also shown is the *Charles Macalester*, which took Washingtonians back and forth to the Marshall Hall amusement park in Maryland for many years. (Mariners' Museum.)

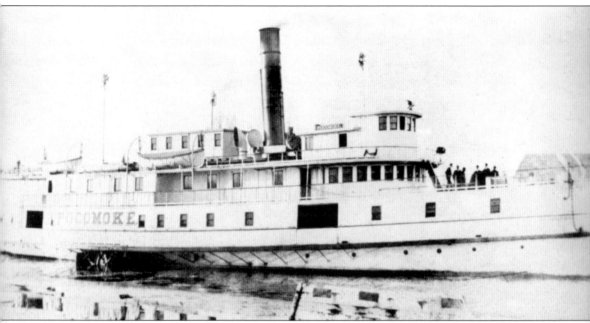

Pocomoke was built in 1891 for the Eastern Shore Steamboat Company. She traveled four times each week on a route between Baltimore, Tangier Island in the bay, and Onancock on the Virginia Eastern Shore, where she is shown. Eventually she came under the ownership of the Baltimore, Chesapeake, and Atlantic Railway, a subsidiary of the PRR. She collided with a freighter in the bay during fog in August 1928. By 1937, she had been reduced to a barge and abandoned. BC&A was sometimes referred to as Black Cinders and Ashes or Before Christ and Afterwards. (Eastern Shore of Virginia Historical Society.)

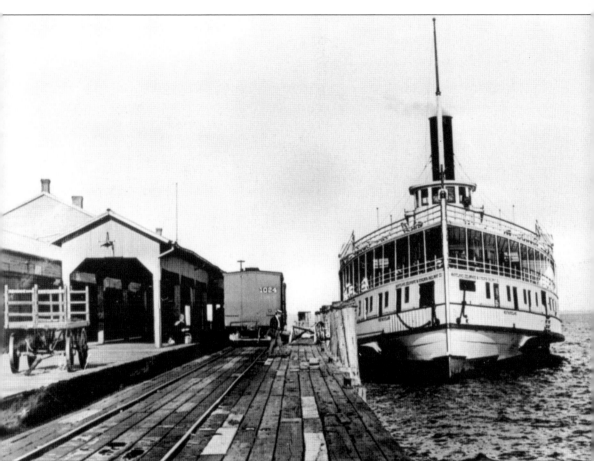

Westmoreland, seen here at the railroad connection at Love Point, Maryland, was built for the Weems Line in 1883. With gold-trimmed paddle-boxes, an eagle atop her pilothouse, and a good host of staterooms, she was known as a "difficult" steamer, always seeming to seek out a sandbar to rest upon in shallow waters. She, too, came under the ownership of the BC&A. She was sold into service as a gravel-hauler in 1924 and dismantled in 1925. (Courtesy Robert Lewis.)

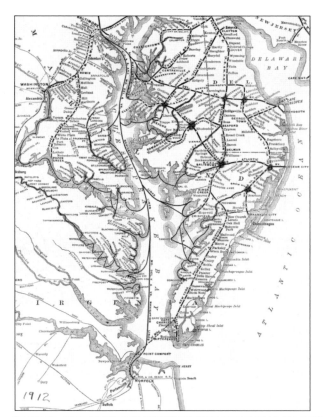

1912

The BC&A rail and steamer routes seemed not to miss any small town in the region of the upper bay, and they extended from Baltimore to the Atlantic Ocean. The steamer route from Baltimore to Cambridge, Maryland, seen here in 1910, took two hours and arrived in one of Maryland's oldest towns, first settled in 1684. A famous resident of Cambridge at the time of this postcard was sharpshooter Annie Oakley of "Buffalo Bill's Wild West." (Courtesy Robert Lewis.)

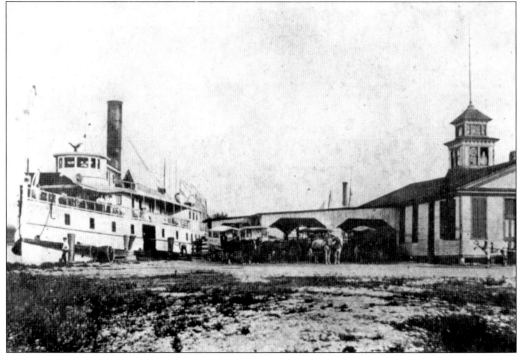

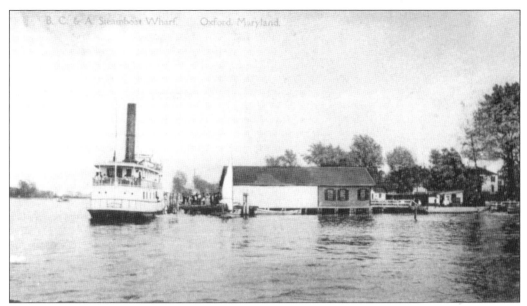

In the late 17th century, Oxford (seen in 1919) and the town of Anne Arundel (now Annapolis) were chosen as the only ports of entry for the province of Maryland. For that reason, Oxford was a bustling international seaport until the American Revolution. After a slumber between wars, post–Civil War Oxford, visited here by the *Chesapeake*, returned to life with the completion of the railroad in 1871 and the export of Chesapeake Bay oysters to the rest of the East Coast. (Courtesy Robert Lewis.)

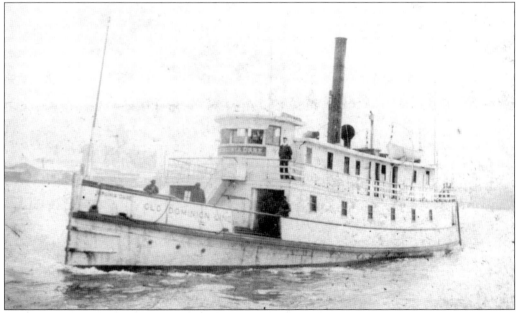

The Old Dominion Line's *Virginia Dare* was a small boat that traveled between Norfolk and New York City. The Old Dominion Line advertised "Short and inexpensive vacations for busy people on beautiful new steamships." Another advertisement promised that "When you go South the old Dominion Line will take you with safety, speed and comfort." (Wilson History Room, Portsmouth Public Library.)

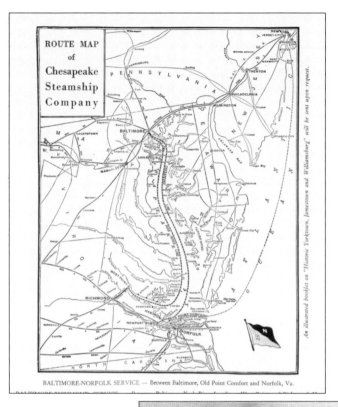

ROUTE MAP of Chesapeake Steamship Company

An illustrated booklet on "Historic Yorktown, Jamestown and Williamsburg" will be sent upon request.

BALTIMORE-NORFOLK SERVICE — Between Baltimore, Old Point Comfort and Norfolk, Va.

In the 1920s, steamer commerce in the region was largely under control of three railroads—the PRR, Seaboard Air Line, and the Southern Railway, which had controlling ownership of the Chesapeake Steamship Company (CSS). With railroad backing, the Chesapeake Line began to become very competitive in the bay, especially against the Old Bay Line. (Maryland Department, Enoch Pratt Free Library.)

The hapless *City of Richmond* was built for the CSS in 1913. Seen here, she is sunk at the pier in West Point, Virginia, in 1915. She would collide with a schooner and sink it four months later and do the same to her sister ship *City of Annapolis* in 1927. She would become one of the last operating bay steamers in 1962. (Mariners' Museum.)

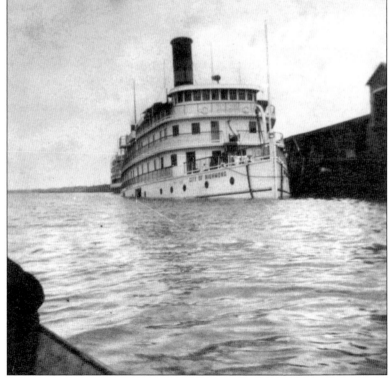

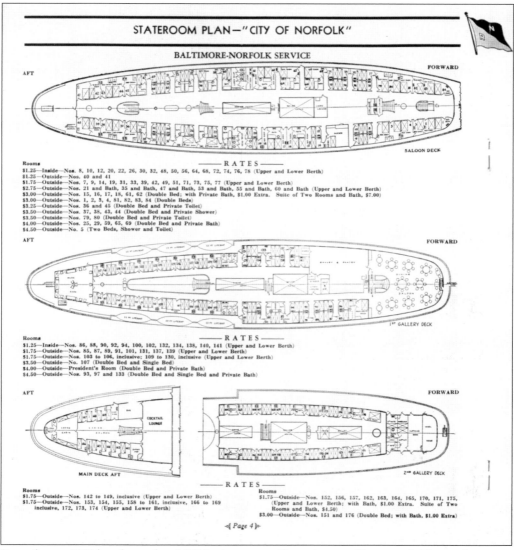

Pages from a CSS brochure, dated 1926, give an excellent picture of bay travel. These schematics of the *City of Norfolk*, put into service by the CSS in 1911, show the spaces and layout of a typical bay steamer of the time. (Maryland Department, Enoch Pratt Free Library.)

Rates and Sailing

SCHEDULE
SUBJECT TO CHANGE WITHOUT NOTICE

RATES:

TO NORFOLK AND OLD POINT

$4.00 one way—30 day round trip, $6.
Special week-end round trip$4.00
(Sold Friday and Saturday, good to return until Monday night)

Staterooms:

Berth Rooms, $1.25 and $1.75.
Berth Rooms, with Bath $2.75.
Bed Rooms, $3.00.
Bed Rooms, with Bath, $4.00.
Twin Bed Rooms, with Bath, $4.50.

Additional persons may occupy staterooms without extra charge

TO RICHMOND AND YORK RIVER LANDINGS
$2.50 Each Way

Staterooms:

Berth Rooms, $1.25, $1.75, and $2.25.
Berth Rooms, with Bath, $2.75 and $3.25.
Bed Rooms, $3.00.
Bed Rooms, with Bath, $4.00.

Additional persons may occupy staterooms without extra charge

SAILING SCHEDULE:
(Standard Time)

NORFOLK AND OLD POINT
Every day including Sunday

SOUTH BOUND

Leave Baltimore (Pier 19 Light Street) 6.30 P. M.
Arrive Old Point (Government Dock) 5.15 A. M.
Arrive Norfolk (Jackson Street) 6.30 A. M.

NORTH BOUND

Leave Norfolk (Jackson Street) 6.15 P. M.
Leave Old Point (Government Dock) 7.15 P. M.
Arrive Baltimore (Pier 19, Light Street) .. 6.30 A. M.

RICHMOND AND YORK RIVER LANDINGS
SOUTH BOUND
MONDAY, WEDNESDAY, FRIDAY

Leave Baltimore (Pier 19, Light Street) .. 6.00 P. M.
Arrive West Point 7.45 A. M.
Leave West Point (Motor Coach) 8.00 A. M.
Arrive Richmond,
(Bus Center, 9th and Broad) 9.00 A. M.

NORTH BOUND
TUESDAY, THURSDAY,
SATURDAY

Leave Richmond,
(Bus Center, 9th and Broad) 4.30 P. M.
Leave West Point 5.30 P. M.
Arrive Baltimore (Pier 19, Light Street) .. 7.00 A. M.

ACCOMMODATIONS AT VIRGINIA BEACH, OLD POINT COMFORT AND OCEAN VIEW

If you'll communicate with the Chesapeake Line office at Pier 19 Light Street or 4 St. Paul Street, full information and details about rates and reservations will be furnished. Phone, South 1310.

VIRGINIA BEACH

The Cavalier Hotel	200 rooms	Idlewhyle Cottage	100 guests
Albemarle Hall	200 guests	Kenilworth Cottage	100 "
Arlington Hotel	100 "	Mertun Cottage	
Atwater Hotel	35 "	Montague	45 guests
Avalon Hotel	110 "	Murray Cottage	30 "
Avamere Cottage		Newcastle	150 "
Barclay Hotel	20 "	New Waverly	150 "
Beachome Apt. Hotel		Ocean Terrace	
Beach Plaza	150 "	Cottage	20 "
Beachwood	45 "	Pinewood	150 "
Burtonia Hotel	75 "	Pocahontas	300 "
Breakers	70 "	Princess Anne	200 "
Chalfonte	200 "	Roanoke	50 "
Conley Cottage		Seaside Cottage	80 "
Courtney Terrace	200 "	Sinclair	
Dolphin Cottage		Spotswood Arms	100 "
Dundee Cottage	40 "	The Shoreham	50 "
Fitzhugh	75 "	Trafton Inn	35 "
Martha Washington	244 guests	Virginia Lee	100 "
Gay-Manor Hotel	85 rooms	Warner Hotel	
Greenwood	50 guests	Woodhouse Cottage	
Hygeia	100 "		

OCEAN VIEW

Atlantic	100 guests	Raleigh	40 guests
Beach Haven	60 "	Richmond	30 "
Brickley Willoughby	25 "	Rustic Willoughby	100 "
Drewery's Hotel	150 "	Seans Cottage	
Bay Cottage	43 "	Shore Drive Hotel	50 "
Cason Cottage		Singleton Cottage	
Degge Cottage		Sterling Cottage	40 "
Lowe	100 "	The Sheerin	27 "
Merrimac	50 rooms	Water View	35 "
Nansemond Hotel	250 guests	Yeates Cottage	
Ocean Terrace	60 "		

OLD POINT

New Chamberlin Hotel

NORFOLK

Hotel Atlantic	150 rooms	Hotel Monticello	300 guests
Hotel Fairfax	300 guests	Hotel New Virginia	85 rooms
Hotel Ghent	75 "	Hotel Norfolk	175 guests
Hotel Lee	175 "	Hotel Southland	160 rooms
Hotel Lorraine	150 rooms	Hotel Victoria	102 "

The schedule includes the resort areas of the lower bay and the times and costs involved in getting to them. (Maryland Department, Enoch Pratt Free Library.)

The traveling public at the present time requires first-class equipment, comfort and luxury. In order to meet this demand the Chesapeake Steamship Company operates two splendid services—the Baltimore-Norfolk Service, running daily between Baltimore, Old Point Comfort and Norfolk, and the Baltimore-Richmond Service, between Baltimore and West Point, daily except Sunday, where through connection is made with Richmond. The Southern Railway operates a Special Steamer Train, with parlor car attached, making no stops between West Point and Richmond and taking only one hour and five minutes.

The steamers "City of Richmond" and "City of Annapolis" ply between Baltimore and West Point. These vessels are in reality floating hotels of the most modern type. They are 277 feet long, 53 feet wide over the guards, and can accommodate 350 passengers. Equipped with telephones in every room, they have all the latest improvements which can add to the comfort and safety of their passengers. The staterooms are well furnished, and all contain running hot and cold water, electric lights, etc. Many of them have double brass beds and connect with bathrooms or shower baths. There are also a number of suites of two rooms with bath between. All bathrooms have both hot and cold fresh and salt water.

The dining rooms are located on the gallery (upper) deck forward and have accommodations for 70 people.

The line is noted for the excellence of its cuisine and has achieved a deservedly fine reputation on this account. Where the quality of the food is always of the very best, properly cooked by first-class chefs, and served by competent stewards, meals on this line are truly a pleasure which the passengers thoroughly appreciate.

A large smoking room and a music room on the gallery deck add to attractions of these beautiful vessels and nothing has been overlooked to make them stand in a class by themselves.

The same things are true of the "City of Baltimore" and "City of Norfolk," which run between Baltimore, Old Point Comfort and Norfolk.

Slightly larger—310 feet long and 60 feet wide—they, too, have rooms en suite with connecting bathrooms; rooms with single, double and twin beds and bathrooms and shower baths galore. On the upper deck is an attractive dance salon, where passengers may enjoy dancing and good music. With the same delightful food and excellent service as on their sister ships, travel on the Lines of the Chesapeake Steamship Company is a pleasure to be looked forward to, and when realized to be talked of and not to be forgotten.

Our Mottoes:

Politeness and Courtesy of Employees

Cleanliness and Good Service

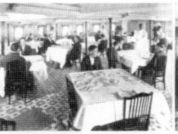

DINING ROOM

DANCE SALON

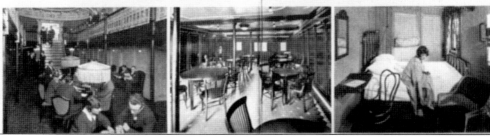

The "excellence of cuisine" promised in the brochure was a given on many of the bay steamers, and it would have been difficult for their galleys to produce anything less. Especially in the warm months, steamer chefs could realize the best recipes of bay culture with the freshest of produce and seafood from the wharves at which they stopped. Blue crab was the central entrée, in all of its variations. (Maryland Department, Enoch Pratt Free Library.)

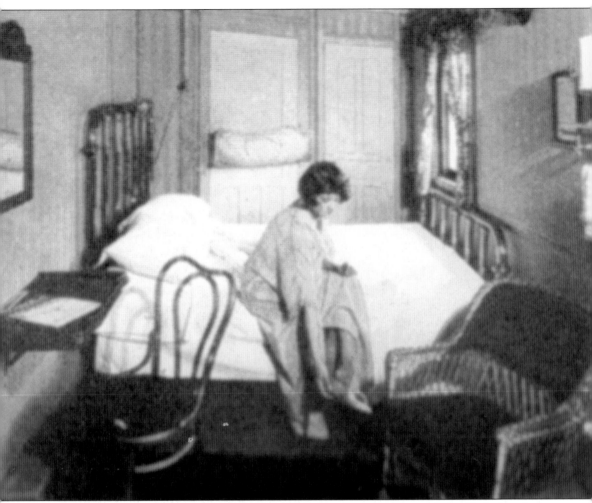

A close-up photograph from the CSS brochure shows an outside cabin with double bed and private bath at the additional rate of $4 for the trip from Norfolk to Baltimore. (Maryland Department, Enoch Pratt Free Library.)

OLD POINT COMFORT

All-Expense Week-End

$14.65 AND UP

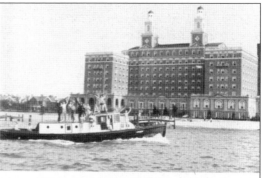

NEW CHAMBERLAIN HOTEL, OLD POINT COMFORT

Leaving Friday, returning Monday A. M. or leaving Saturday, returning Tuesday A. M.

During the early Indian wars, one of the famous hostile Indian chiefs was taken prisoner and interned as hostage for his tribe's good behavior at Old Point Comfort, Virginia. From all along the coast—Philadelphia, and New York, Boston and Albany, Baltimore and Washington, Richmond and Charleston, Savannah and Atlanta—came curious visitors who braved the hardships of early 19th century travel to see Uncle Sam's prize prisoner!

When they arrived they saw the Chief all right—but they discovered something a lot more interesting! For Old Point Comfort was the ideal year-round resort and watering place. Its lovely climate, its moderate temperature both Winter and Summer soon made it the mecca of American aristocracy, and—if your family has lived in Baltimore for several generations—it's almost an even money bet that some of your relatives "honeymooned" there.

Today a luxurious hotel and the social attractions of the numerous army and navy posts at Fortress Monroe and Hampton Roads add to its natural advantages. The New Chamberlain Hotel also boasts indoor and outdoor swimming pools, a completely equipped health studio with electric cabinet baths, massages, sprays, packs, intestinal irrigators, corrective calisthenics, and breathings, and Nauheim baths for heart and blood pressure.

The all-expense week-end at Old Point Comfort starts at $14.65. It includes round trip transportation, meals on the steamer both ways and accommodations and meals for two days and one night at the New Chamberlain Hotel—which is now under the personal management of Mr. Sidney Banks.

OCEAN VIEW ALL-EXPENSE WEEK

$11.90 AND UP

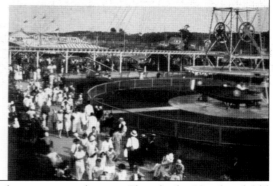

Leaving Friday, returning Monday A. M. or leaving Saturday, returning Tuesday A. M.

Least expensive—but by no means least enjoyable—is the all-expense week-end at Ocean View which starts at $11.90. It includes transportation both ways, de-luxe meals aboard the steamer and room and meals for two days and one night at Ocean View. It is particularly appealing to those who seek a more restful and less strenuous vacation. Ocean View offers splendid bathing, swimming, boating and the best fishing grounds in the neighborhood.

Full information as to hotel accommodations and rates is available at the offices of the Chesapeake Line at 4 St. Paul Street or just call South 1310.

A 1930s brochure of the CSS offered a weekend excursion to the new Chamberlin Hotel and Old Point Comfort starting at the odd price of $14.65. The brochure misspells the name of the hotel, as often happened, and a story about an imprisoned Native American chief can't be confirmed (nearby Hampton Institute, however, was one of the Native American boarding schools of the late 19th century). The Ocean View Amusement Park sat directly across the bay from Old Point Comfort and not far from the earlier location of the Jamestown Exposition. The electric streetcars of the late 1800s promoted the development of Ocean View by bringing tourists and residents alike from the center of Norfolk to the resort on the bay. (Maryland Department, Enoch Pratt Free Library.)

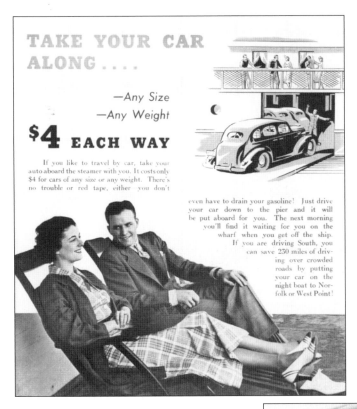

TAKE YOUR CAR ALONG

—Any Size
—Any Weight

$4 EACH WAY

If you like to travel by car, take your auto aboard the steamer with you. It costs only $4 for cars of any size or any weight. There's no trouble or red tape, either you don't even have to drain your gasoline! Just drive your car down to the pier and it will be put aboard for you. The next morning you'll find it waiting for you on the wharf when you get off the ship. If you are driving South, you can save 230 miles of driving over crowded roads by putting your car on the night boat to Norfolk or West Point!

For both the steamship lines and the railroads that owned most of them, the development of the automobile was the beginning of an end that might not have been fully foreseen in the 1930s. Increasingly the bay steamers were reconfigured to carry the cars of their passengers, a strategy to keep the passengers on the water instead of the highways, but it foretold what was to come, especially after World War II. The reference to the draining of gas tanks reflected a change in law that had previously held that vehicles on steamboats had to be drained of gasoline before carriage. (Maryland Department, Enoch Pratt Free Library.)

However she got there, she was having a good time. This photograph, taken at the Baltimore wharf at Old Point Comfort, dated 1937, contains only a note in pencil on the back: "Mary Smith, later Mrs. Carlisle Tiller." (Casemate Museum.)

Five

TO THE BEACHES!

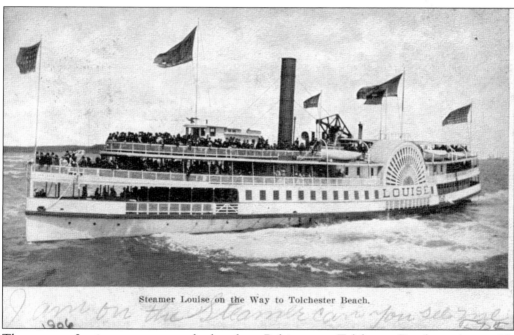

Steamer Louise on the Way to Tolchester Beach.

The steamer *Louise* moves across the bay from Baltimore to Tolchester Beach on August 30, 1906. It did not take the coming Labor Day holiday to crowd the boat to its rails beneath flags fluttering in the wind. The Chesapeake Bay and its close-in tributaries contained nearly 12,000 miles of shoreline, more than the American West Coast, and in the summer especially, its beaches were well used. Some of them held amusement parks and resort areas created by the steamboat companies to generate passengers and extend other business interests. Tolchester Beach in Kent County, Maryland, directly across the bay from Baltimore, had started as a 10-acre amusement park in 1877. During its 85 years, it expanded to 155 acres and at its height was serviced by six steamers that brought as many as 20,000 to the beach each weekend. (Maryland Department, Enoch Pratt Free Library.)

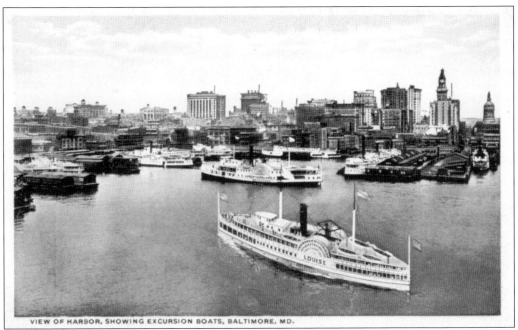

VIEW OF HARBOR, SHOWING EXCURSION BOATS, BALTIMORE, MD.

Postcard views of the *Louise* show her entering Baltimore harbor and under moonlight on a card postmarked April 24, 1914. Built in the Civil War and remodeled to allow large, open dance floors that could accommodate the orchestras and big bands of the era, she could carry 2,500 passengers at a time. A popular anecdote held that she was so set into the Tolchester run that on a rare excursion to another destination, she refused to change course in the new direction. She relented when her captain scolded, "C'mon, you ole fool! You ain't going to Tolchester today! Come about!" *Louise* was a beloved boat, retired in the mid-1920s, in part because she couldn't accommodate cars and trucks. She was replaced on the run by the *Express*, but many in Baltimore refused to ride on the newer ship. (Maryland Department, Enoch Pratt Free Library.)

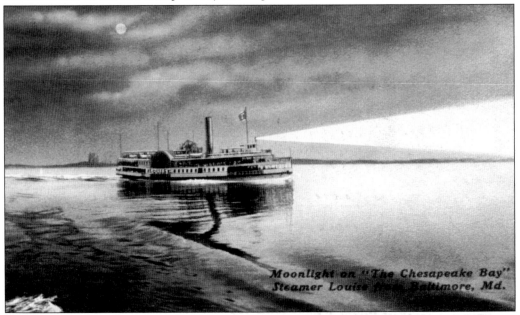

Moonlight on "The Chesapeake Bay"
Steamer Louise from Baltimore, Md.

The Wilson Line had its beginnings in Delaware and Pennsylvania in 1881. It expanded to Baltimore in 1931 and ran its popular ship *State of Delaware* for cruises on the bay or charters to the beaches. Passengers on the ship could sit in large armchairs, watch movies in the open air, or dance to live bands on the lower decks. In 1941, Wilson renovated its 1909 boat *City of Washington* into the *Bay Belle*. But the *Bay Belle* worked for just one season until she was pulled into World War II for other service. After the war, and under new ownership, she ran routes to the declining Chesapeake and Tolchester Beaches until 1962. (Chesapeake Beach Railway Museum.)

WILSON LINE STEAMER "STATE OF DELAWARE"

MOONLIGHT MELODY CRUISE

The Wilson Line steamer "STATE OF DELAWARE" sails from Pier 8, Light Street each evening, including Sundays and Holidays, at 8:30 P. M. for a moonlight cruise on Chesapeake Bay with dancing and talking pictures, returning at 11:30 P. M.

For three hours you sail through the breezes. You dance if you want to, and you will probably want to, on our extraordinarily large dancing deck where one of Baltimore's leading orchestras creates the rhythm and the atmosphere. You take time out to see and hear the feature "talkie" on the top deck. The pictures are changed twice weekly. The showing of motion pictures on moonlight cruises is not only an innovation in Baltimore, originated by the Wilson Line, but is unusual among moonlight cruises the country over.

You return so thoroughly cool, so completely relaxed and refreshed that your sleep is sound and restful throughout the night that follows.

TELEPHONE PLAZA—3517

SPECIAL RATES TO CHURCHES, ORGANIZATIONS, CLUBS, ETC.

The steamer "STATE OF DELAWARE" may be obtained for Excursions to Seaside Park or for Moonlight Cruises, either on a percentage basis or you may charter the steamer outright for your own trip.

Many organizations each year take advantage of these special rates to continue their social activities during the summer and at the same time put money in their treasuries. The money-making possibilities for your organization on a well-conducted excursion or outing on a Wilson Line steamer are surprising.

The Wilson Line will gladly have one of its representatives call on your organization to give them full particulars about an excursion, and assist in the formation of your plans.

Please write to our Baltimore Office or telephone Plaza 3517 for additional information.

WHEN YOU VISIT PHILADELPHIA OR WASHINGTON

The Wilson Line operates Excursion Steamers out of Philadelphia and Washington too. All summer long there are day trips and evening trips with dancing. By day the Philadelphia steamers operate to Riverview Beach, 40 miles down the Delaware River. They also ply between Philadelphia, Chester, Pennsgrove and Wilmington, all the year round. In Washington there are interesting day trips to Marshall Hall Park and to historic Mt. Vernon and evening excursions down the Potomac River. When you are in these cities, take these popular boat rides.

AIR VIEW OF FORT McHENRY IN FOREGROUND, WHERE THE STAR SPANGLED BANNER WAS WRITTEN

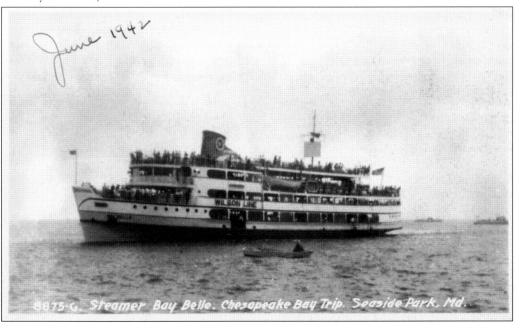

June 1942

8875-G. Steamer Bay Belle. Chesapeake Bay Trip. Seaside Park, Md.

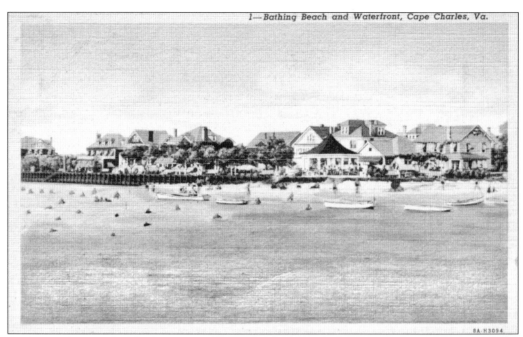

At the southern end of the bay, Cape Charles, Virginia, was a hard-working town devoted to the transfer of passengers and freight cars between trains to and from the Northeast and passage across the 20 miles of bay waters to Norfolk and the Southeast. In the early part of the 20th century, it was a very sociable place to live and work. Townspeople were joined by the farmers of the rural Eastern Shore on the quiet beaches across from the mansions of Bay Avenue. The postcard below misnames the street and shows the NYP&N ferry *Princess Anne* entering the harbor after a trip from Norfolk and Old Point Comfort. (Cape Charles Historical Society.)

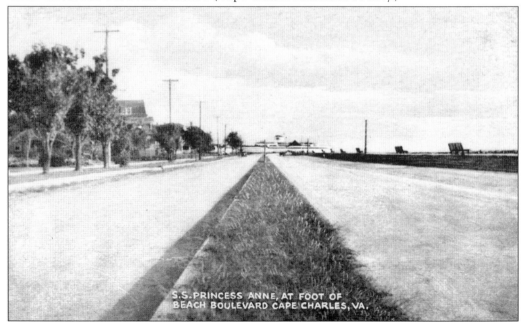

S.S. PRINCESS ANNE, AT FOOT OF BEACH BOULEVARD CAPE CHARLES, VA.

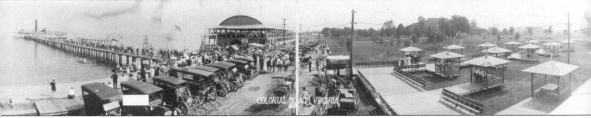

The steamer *St. Johns* is docked at Colonial Beach on the Potomac River in Virginia's Westmoreland County. The county had produced two American presidents, George Washington and James Monroe, and found itself on the tenuous dividing line between North and South in the Civil War. Steamboat service to Westmoreland County had begun in 1855, and in 1893, the Colonial Beach Improvement Company built a wharf and opened a summer resort. The resort, seen here in 1913, was prized for its great beaches and seafood and had a reputation for many years for "free-wheeling entertainment" and a slightly easy atmosphere. The *St. Johns* shuttled from Washington to Colonial Beach starting in 1902. In 1941, she was purchased at a price of $25,000 to replace the unpopular *Express*, renamed *Bombay* and subsequently renamed *Tolchester*. Boats ran to Colonial Beach into the late 1940s, when patronage of the resort began its final decline. (Library of Congress.)

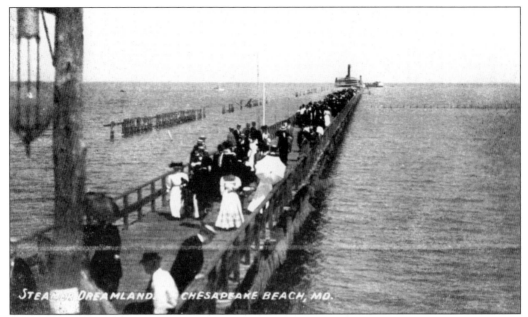

One of the most popular and accessible resorts was Chesapeake Beach in Calvert County, Maryland. The long pier was a necessity born thanks to the geography of the bay. Its surface area is 4,480 square miles, but its average depth is just 21 feet, growing shallow closer in to shore, while the average depth requirement for most steamers was 10 feet. Sometimes it seemed they needed to dock at lengths into the bay that rendered them practically invisible from the shore. (Chesapeake Beach Railway Museum.)

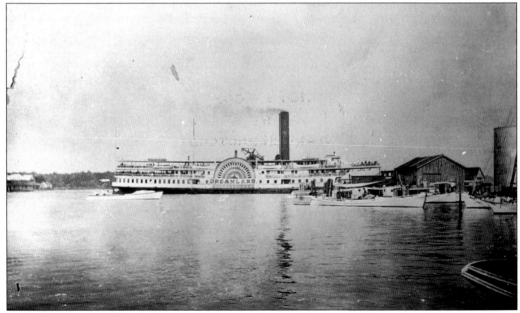

A closer view of *Dreamland* shows the steamboat that was built in 1878 as *Republic* for work between Philadelphia and Cape May, New Jersey. Later on, she was owned by the Dreamland Excursion Company of New York and shuttled passengers between West 129th Street in Manhattan and Coney Island. (Chesapeake Beach Railway Museum.)

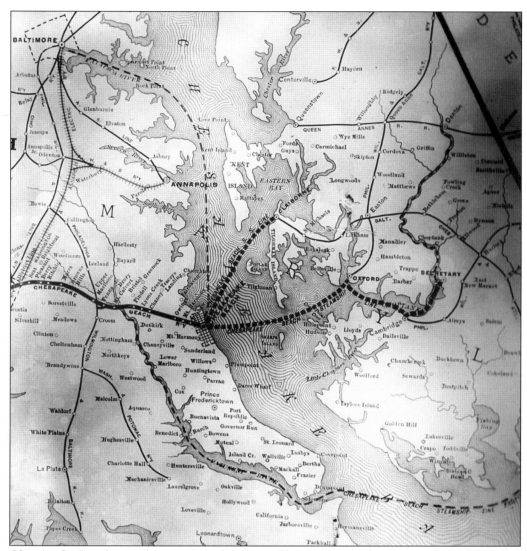

Chesapeake Beach was the creation of a group of businessmen who perceived a railroad that would transport the sweaty summertime residents of Washington, D.C., to the windswept shores of the bay. After fits and starts, the project came under the supervision of Otto Mears, a Russian immigrant who rose from an orphan's life on the streets of San Francisco to building railroads in Colorado and then the East. In 1897, Mears began construction of the Washington and Chesapeake Beach Railroad from the District of Columbia (not shown) to the bay. After legal skirmishes that pitted the railroad's need to bridge the Patuxent River against the need of the Weems Line to navigate the crossing, the track was completed in 1900. It was joined with the pier that brought steamers from Baltimore, and the resort was opened. The establishment of a Chesapeake Beach Steamship Line, as envisioned on the map, was never realized. (Chesapeake Beach Railway Museum.)

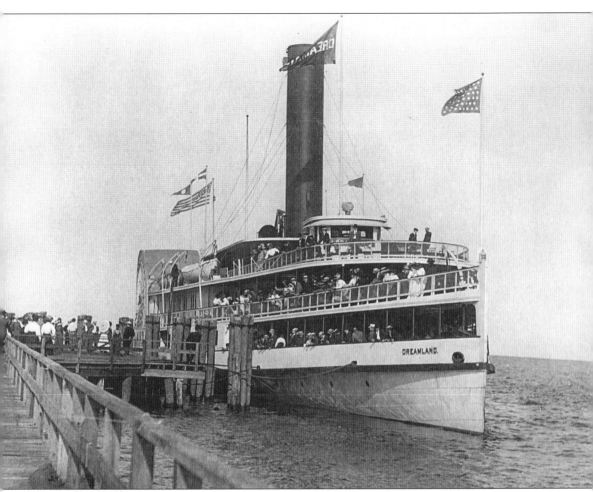

In a business in which names of venerable steamers could be changed overnight by new ownership, *Dreamland* was an example of the opposite: the power of a name to create its own change. Named after an excursion company in New York, she was purchased for $30,000 and retained that name under new ownership for her run from Baltimore. She became so popular on that route that her passengers began to refer to Chesapeake Beach itself as Dreamland. And when she was replaced on the route in 1925 by the *State of Delaware*, her passengers retained Dreamland as their nickname for the new boat. At 284 feet, the original *Dreamland* was the largest excursion boat on the bay. She cruised at 14 miles per hour but could reach 21 if necessary. Meals were served by waiters in white coats for 50¢. A dark-paneled lounge included upholstered furniture, and an eight-piece orchestra provided entertainment. (Chesapeake Beach Railway Museum.)

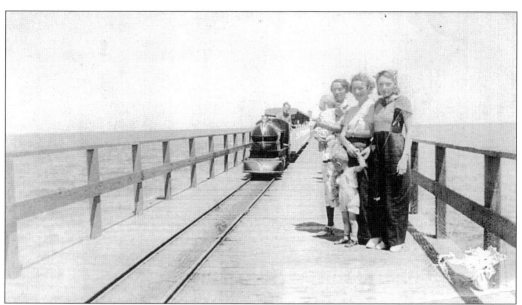

To some, the half-mile trek from the *Dreamland* to the shore seemed as long a journey as the several hours it took to arrive from Baltimore, and not nearly as pleasant. Eventually a miniature railroad was put in place for the full length of the pier. For many who traveled by steamer, the trip was an expedition worthy of more than enough trunks and suitcases to supply their varied needs over a few days' visit. When luggage arrived on shore, it was carried to hotels by ox-drawn carts at a cost of 10¢ per bag. (Chesapeake Beach Railway Museum.)

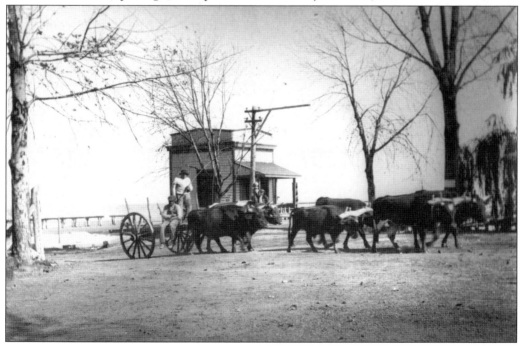

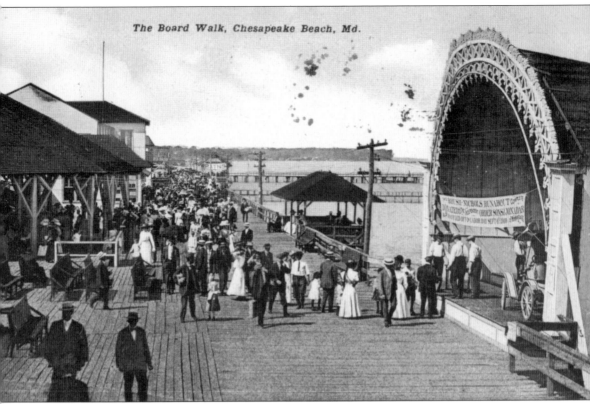

The Board Walk, Chesapeake Beach, Md.

The written message on the back of this postcard reads: "This is a very beautiful place. Will be dancing this afternoon and I will have a dance for you. Back in Washington tom'w." Until 1928, the boardwalk was a mile long and itself 300 feet offshore from the beach. The Belvedere hotel looked down from a hillside above the bay. Intended to be marketed to the well-to-do, it became instead a middle-class amusement park and resort with a roller coaster, slot machines, carnival attractions, and dance halls. The automobile on the small stage is a Brush Runabout set to be raffled off on Labor Day, 1909. The Brush was a precursor to Pontiac in automotive history. Its white ash frame sat on coil springs and maple axles. A one-cylinder engine developed 10 horsepower and propelled the car up to 18 miles per hour with a two-speed transmission. (Chesapeake Beach Railway Museum.)

Despite its slightly honky-tonk atmosphere, Chesapeake Beach was a welcome and refreshing respite from the hot summers in the city. As did many resort areas of the day, it advertised its supposed health-giving attractions and activities. Its amusement park came to be known around the bay as Seaside. Over the years, the bands of John Phillips Souza and Tommy and Jimmy Dorsey performed, and German bands played in beer gardens, a particular attraction for the ethnic communities of Baltimore. Weekends sometimes brought rowdyism, and those arrested were merely put in a jail until the next train out and told not to return. During Prohibition, speakeasies, and raids to shut them down, were frequent, but Chesapeake Beach retained its reputation as a place for good beer and easy pleasure. (Chesapeake Beach Railway Museum.)

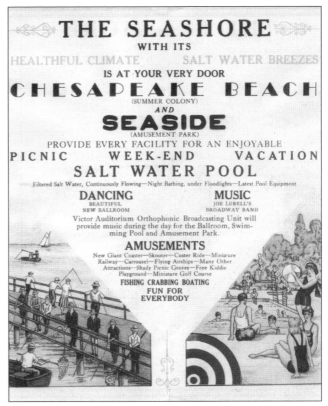

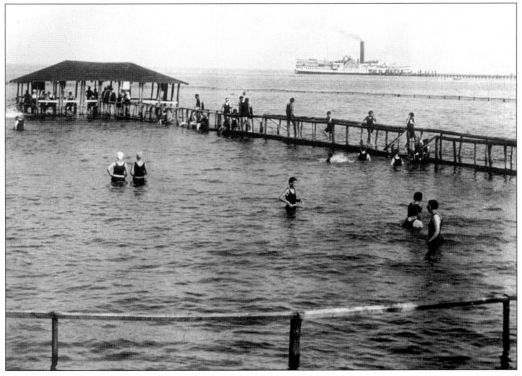

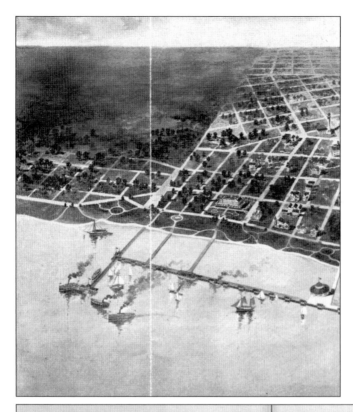

As envisioned by Otto Mears and his partners, Chesapeake Beach would evolve beyond its resort status into the equivalent of a planned community on the bay. The plan was called Chesapeake Beach Reservation, and it was to include several luxury hotels, a first-class residential area of larger homes, and other services of a small town. A marina and racetrack would be crowning touches. The plan was never realized, but the park continued to be sold successfully as a place unlike any other that was available to residents of Baltimore and Washington. (Chesapeake Beach Railway Museum.)

Chesapeake Beach

NEW AND MODERN

Presents Attractions Not Offered by any other
Resort this Side of Atlantic City

Finest Salt Water Bathing

) FISHING CRABBING SAILING (

Beautiful Grounds
For Picnic and Camping Parties

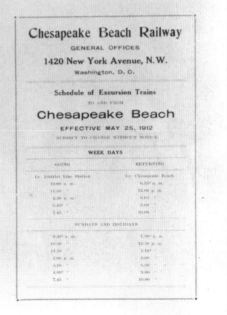

Chesapeake Beach Railway

GENERAL OFFICES

1420 New York Avenue, N.W.
Washington, D. C.

Schedule of Excursion Trains
TO AND FROM

Chesapeake Beach

EFFECTIVE MAY 25, 1912
SUBJECT TO CHANGE WITHOUT NOTICE

WEEK DAYS	
GOING	RETURNING
Lv. District Line Station	Lv. Chesapeake Beach
10.00 a. m.	9.55* a. m.
11.30	12.06 p. m.
2.30 p. m.	6.04 "
5.45* "	8.00 "
7.45 "	10.00 "

SUNDAYS AND HOLIDAYS	
9.30* a. m.	7.00* a. m.
10.30 "	12.30 p. m.
11.30 "	2.10* "
2.00 p. m.	6.00 "
3.10 "	8.00 "
4.00* "	9.00 "
7.45 "	10.00 "

In the 1920s, buses and automobiles supplemented rail and water in bringing travelers to Chesapeake Beach. Buses of the Baltimore Transit Service offered regular service, and five trains traveled between Washington and Seaside each weekday, more on the weekends. Rail service had run continuously since 1900, but by 1935, the one-two punch of the Depression and the automobile had bankrupted the railroad. The railway terminal (bottom left) was left standing into the 21st century to serve as the Chesapeake Beach Railway Museum, containing artifacts, archives, and exhibits related to the former resort and amusement park. (Chesapeake Beach Railway Museum.)

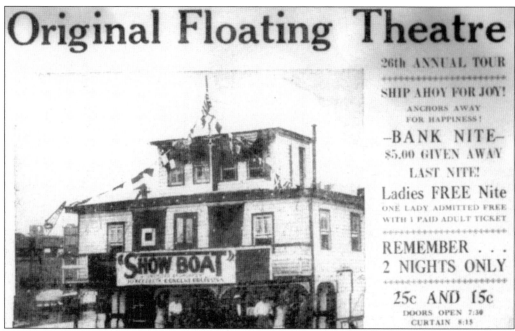

Original Floating Theatre

26th ANNUAL TOUR

SHIP AHOY FOR JOY!

ANCHORS AWAY
FOR HAPPINESS!

–BANK NITE–

$5.00 GIVEN AWAY

LAST NITE!

Ladies FREE Nite

ONE LADY ADMITTED FREE
WITH 1 PAID ADULT TICKET

REMEMBER . . .
2 NIGHTS ONLY

25c AND 15c

DOORS OPEN 7:30
CURTAIN 8:15

Among the more exotic transports on the bay was *Play House* or *Showboat*, advertised here c. 1915, thought to be the only floating theater on the Atlantic coast. Each summer, she traveled up one side of the bay and down the other, ending the year with a week in Norfolk. Sturdy enough for the challenges of the bay, she contained a 19-foot stage, 8 dressing rooms, and seating for 700. (Essex County Museum and Historical Society.)

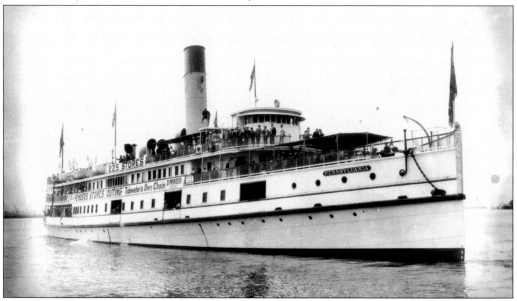

The *Pennsylvania* belonged to the fleet of the NYP&N Railroad. Though *Pennsylvania* was a hard-working ferry for railroad passengers between Cape Charles and Norfolk, she was occasionally used for special events and beach outings, as in this charter by employees of the Pender Company on August 12, 1925. She had a capacity of 400 passengers. (Kirn Library, Sargeant Memorial Room.)

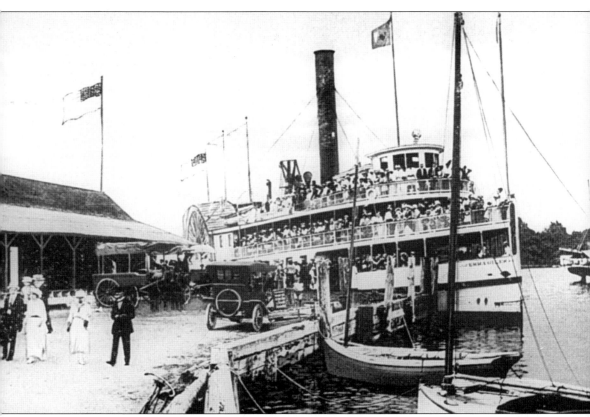

The *Emma Giles*, seen here at Annapolis wharf, may have been the most proficient and beloved of all the bay steamers. Brought to life in 1887 and named after a little girl, she did everything there was to do on the bay for the next 50 years. She was reproduced in art, song, and poetry, much of it still available in the 21st century. She was built for the Tolchester Line and financed with an extraordinary condition attached: the boat would be named after the lender's daughter. In February 1887, young Emma Giles herself broke the champagne bottle against her bow, and the boat entered service as both a substantial freight and livestock hauler and a large and luxurious passenger carrier. She traveled with piano players and orchestras, a central cherry wood staircase, and elegant furnishings. Her arrival at the country wharves of the bay was always a big event. "She looked like the Titanic when she came into the West River," a resident was quoted in the regional newspaper *New Bay Times*. "It was the highlight of our lives. We'd hitch a ride to Chalk Point and swim back—about 100 yards." (Calvert Marine Museum.)

The "Emma Giles" After Collision In Bay

On New Year's Day, 1924, front-page headlines across the bay community reported on the collision of the popular *Emma Giles* with the SS *Steel Trader*, an oceangoing freighter owned by U.S. Steel. Though the two boats had taken steps to avoid each other in a heavy fog near the Little Choptank River, *Emma Giles* was sideswiped on her starboard side, destroying 250 square feet of deck and her side paddle. None of the 52 passengers and crew was hurt, and the steamboat was eventually towed back into Baltimore Harbor by the tug *Britannia*. After hearings, weather was officially blamed for the accident; indeed, heavy fog was the cause of hundreds of collisions during the steamer era. The *Emma Giles* recovered and continued her work until Tolchester Beach failed in 1937. She was converted to an automobile carrier and eventually scrapped. (Calvert Marine Museum.)

African Americans formed the most essential workforce of the steamer era, and they were also passengers on segregated boats. It's probable that these were workers, assembled at Solomon's Wharf in Maryland, where the Patuxent River meets the bay. Blacks worked as stewards, waiters, deckhands, stevedores, and firemen, but there is very little recorded history about their work. In 1983, the author conducted an oral-history interview with 90-year-old Willie Mae Evans of Norfolk, who had worked for 12 years on the Norfolk-to-Washington steamer as a bed maker, glass washer, and drink server. Speaking of the white passengers and black workers, she said, "That was the best job I had. People liked you and you liked them. Every night I was either going to Washington or coming to Norfolk. I made pretty good tips at night during World War II." Tips were important because her salary was about $70 per month. She was once involved in a wreck in Hampton Roads Harbor (described on page 114) and became trapped in a cabin full of rushing water. She didn't work much longer after that. "I didn't like much getting killed myself," she said. (Calvert Marine Museum.)

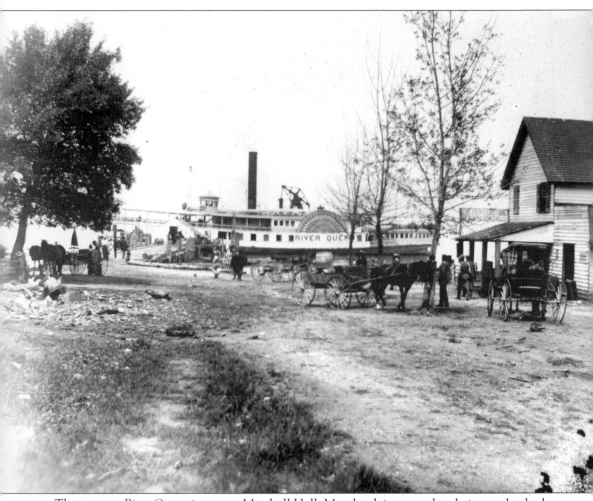

The steamer *River Queen* is seen at Marshall Hall, Maryland, in an undated picture. In the later years of her life until 1911, she carried passengers to Notley Hall, an amusement park owned and operated by African Americans. Other segregated steamers included the popular *Starlight*, which was captained by Capt. George Brown on runs to the Brown's Grove on Rock Creek, owned by the captain and described in advertisements as "the only park in the State of Maryland run exclusively for Colored People and by Colored People." Eventually the *Starlight*, which also operated moonlight cruises on the bay, was renamed *Favorite* and ran until 1928. (Calvert Marine Museum.)

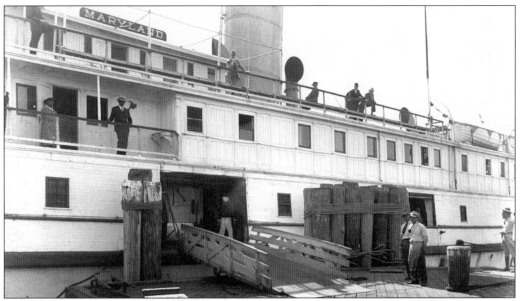

Use of the steamers for freight, livestock, and produce is not as well recorded in history as is passenger traffic. Here the NYP&N steamer *Maryland* opens her freight holds to the wharf at Old Point Comfort in 1937. Agriculture was a key beneficiary. A *Washington Post* article of April 6, 1910, reported, "This whole territory will be given a daily outlet for its products, which it has never had before . . . as to make it profitable for the farms all along the river to increase materially their productiveness." (Hampton History Museum.)

The open waters of the bay were often the only destination needed. The Wilson Line's *Dixie* divided its time between passenger traffic back and forth to Seaside Park at Chesapeake Beach by day and aimless moonlight cruises at night. (Chesapeake Beach Railway Museum.)

MEET AND ENJOY THE ASSOCIATION OF NEW FRIENDS ABOARD THE LEVIN J. MARVEL

While she sails out from Baltimore into Chesapeake Bay. Help us hoist her sails and we will spend happy summer days cruising out into the traditionally historic waters far from today's turbulent civilization yet so enjoyable that time will pass unnoticed and your only wish will be that your vacation cruise never ends. You will avoid all conventionalities; you need not worry about a wardrobe, you play, you loaf, you fish and mingle with friends from many parts of the country who may be shopkeepers, big business men, little business men, doctors, lawyers, housewives, stenographers, engineers and musicians who, like yourself, are out to enjoy this **vacation dream made real.**

THE CAPTAIN AND THE SCHOONER

The Skipper is a Veteran of the Chesapeake and his sole desire will be to serve and make your stay enjoyable and comfortable. The LEVIN J. MARVEL is a sturdy 3 Master, converted, coastal-trading ship; outfitted for Vacation Cruises and meets all requirements of maritime safety and standards.

CABINS

Each cabin accommodates 2 persons, has an individual porthole, separate companionway, 7 foot head clearance, basin with running water, electric lights and is furnished with built-in bunks equipped with modern springs and mattresses.

ENTERTAINMENT

The Cruise provides all types of amusement— deck games and other specialties. The hostess will have charge of all details. Also, on board for your added pleasure, when the MARVEL is riding at anchor, will be two small SAILING DINGHIES and two ROW BOATS for private party use.

The *Levin J. Marvel* was a three-master built in 1881 as a coastal trader and converted in 1944 into a deluxe yacht that invited passengers to help work the sails. By 1955, she had fallen into disrepair and a seedy appearance. On August 11 of that year, she left Cambridge Harbor and headed out into calm seas. At the same time, Hurricane Connie was coming up the East Coast, pushing drenching rains and 50-mile-per-hour winds into the bay. At midday August 12, the *Marvel* began to take on water and lost the use of her engines. She raised sail and attempted, unsuccessfully, to reach safe harbor. At 1 p.m., a swell raised the bow and turned the ship sideways to punishing wind. An hour later, the call was made to abandon ship, and for the most part, passengers ended up in the water in lifejackets as they watched her break apart. Ultimately 14 passengers and crew were lost, and the event became one of the worst maritime disasters in the history of the bay. (Maryland Department, Enoch Pratt Free Library.)

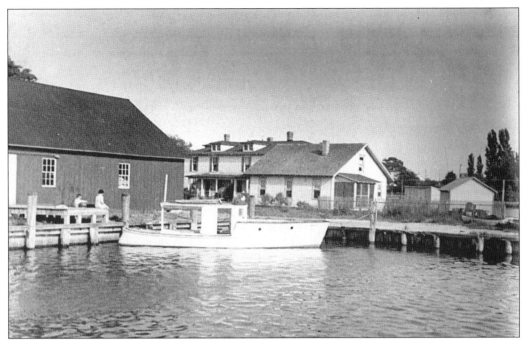

Though visited regularly by the large and noisy steamers, the smaller harbors of the bay worked and played hard on smaller, more quiet scales. Onancock on Onancock Creek dates to 1680 when it was known as Port Scarburgh. American Presbyterianism was founded in 1699 by town resident Francis Makemie. The wharf has remained active for more than 300 years as a point of work and pleasure boats on the bay. In the early 20th century, it was a major port for the distribution of Eastern Shore potatoes up and down the East Coast by way of the steamers and trains of the BC&A and NYP&N. (Eastern Shore of Virginia Historical Society.)

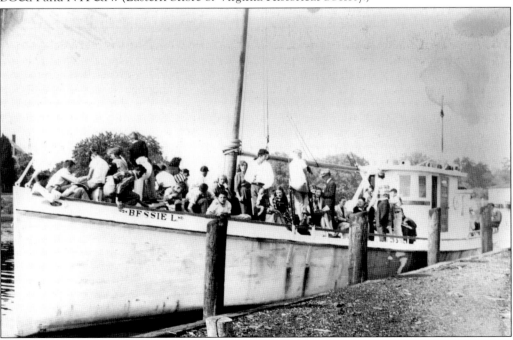

Whether out on the water in the constant summer traffic of other pleasure and commercial boats or pulled up on a beach, as in these pictures from Virginia's Eastern Shore, the human use of the bay in the 20th century began to become more for recreation than for travel and commerce. Agriculture and seafood remained important, but not as much as in the past. And the development of small historic ports into the travel and resort destinations that had been encouraged by the bay steamers planted seeds that replaced farms and fishing with homes and resorts. (Eastern Shore of Virginia Historical Society.)

Development of the bay would contribute to a regional population of 15 million by the end of the 20th century. Inhabitants ranged from the waterfront wealthy with personal yachts kept in exclusive marinas to those who still worked the water for its seafood and ran its pleasure boats in tourist season. The *Spirit of 76*, seen here at Onancock, took visitors and residents back and forth from the Eastern Shore mainland to Tangier Island, about 20 miles offshore. The island was first discovered by Capt. John Smith in his 1608 explorations of the bay and remains inhabited by watermen and their families at the beginning of the 21st century, though erosion and the decline in fishing threatens its continued livelihood. (Eastern Shore of Virginia Historical Society.)

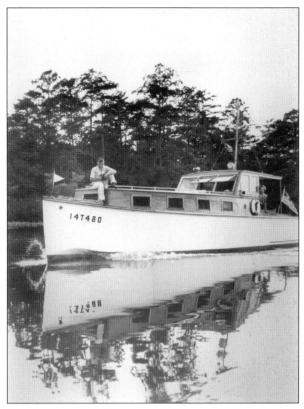

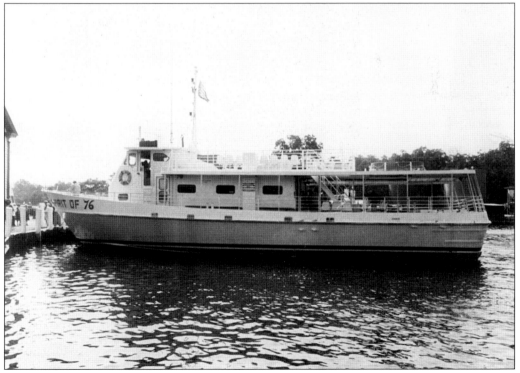

With the water so accessible and the boats and ships that crossed its waters so numerous, anybody, and their dog, could enjoy the Chesapeake Bay on a warm summer's day. (Eastern Shore of Virginia Historical Society.)

Six

THE LOSSES OF WAR

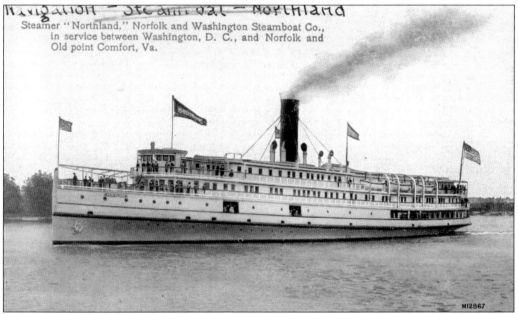

Steamer "Northland," Norfolk and Washington Steamboat Co.,
in service between Washington, D. C., and Norfolk and
Old point Comfort, Va.

Seen in a happier time, the Norfolk and Washington Steamboat Company's *Northland* was just one of the many steamers that would see what might be called their finest and final hours in World War II. Even those that made it through the war, either at home or in brave service overseas, would not eventually survive the effect of the war's interruption of their lives on the bay. In 1942, the War Shipping Administration requisitioned most usable steamboats in the American East, many for transfer to Great Britain. They could not be warships (though many met hostile action), but they could be converted to hospital, training, and small cargo ships. *Northland* and its sister *Southland* were both taken from N&W, leaving the company only with the *District of Columbia* and an inferior replacement ship during and after the war. In 1948, the *District of Columbia* was involved in a collision with an oil tanker, and the company made the decision to cease operation. *Northland* and *Southland* were not returned to America after the war, going instead to China. (Maryland Department, Enoch Pratt Free Library.)

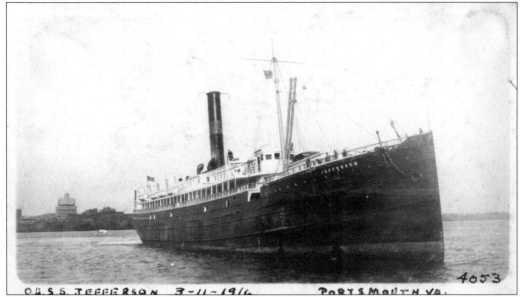

O.D.S.S. JEFFERSON 3-11-1916 PORTSMOUTH VA.

4053

War service for the bay steamers had taken place on a smaller scale in World War I. The Old Dominion Steamship Line's *Jefferson* had been chartered by the U.S. Navy and converted to a mine planter in 1918 under the name *Quinnebaug*. In the company of British destroyers, and under attack from German submarines, she planted more than 6,000 mines from the Orkney Islands to the Norwegian coast and was returned to ODSS for passenger service in 1919. (Wilson History Room, Portsmouth Public Library.)

With her large capacity for freight and sleeping compartments, *Eastern Shore* was a good candidate for service in the war. She is seen here, probably near Great Bridge, Virginia, in 1939 and after undergoing a conversion that removed most of her interior fittings. With the shielding of her foredeck against over-washing seas, she became featureless and, like many of her fellow conscripts, barely recognizable. (Mariners' Museum.)

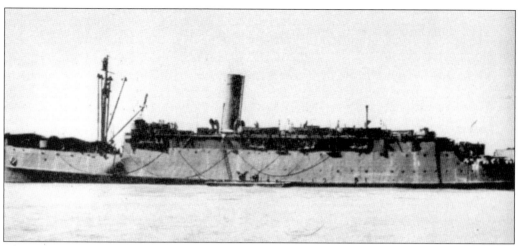

The *State of Maryland* of the Old Bay Line had become something of a heroine among the steamers after forging head-on through the devastating hurricane of 1933 with barely a dent. After that, she was one of the superstars of the bay, but the indignity of naval cladding took much of her superstructure and all of her beauty. Service during the war drove her to the scrap heap. (U.S. Army.)

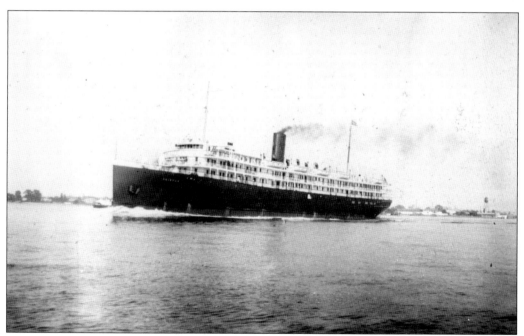

Like the Old Bay Line, Merchants and Miners lost many of it ships to service in the war. The company was able to reinstitute limited services at its conclusion, but it was not considered financially viable enough to return to its former strength. The company was officially liquidated in 1952. The *Fairfax*, shown here in 1931, was sold to China in 1946 and renamed *Chung Hsing*. (Wilson History Room, Portsmouth Public Library.)

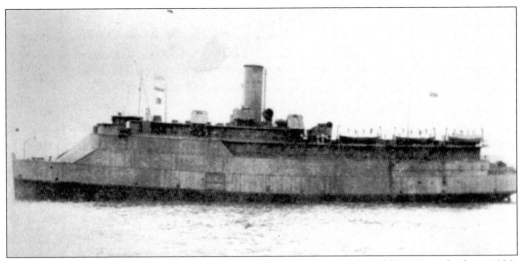

Yorktown had been an elegant and nimble three-deck steamer of the Old Bay Line built in 1928. In September 1942, while in convoy with sister ship *President Warfield* east of Newfoundland, the two bay steamers fell under the attack of German U-boats. *Yorktown* was sunk in three minutes' time, but *President Warfield* made it safely to the British coast, the first stop in what would become a very distinguished history. (Coast Guard.)

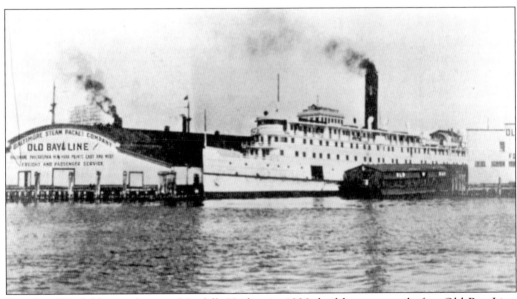

President Warfield, seen here in Norfolk Harbor in 1930, had been named after Old Bay Line president Solomon Davies Warfield and first put into service in 1928. With a speed of nearly 20 miles per hour and a crew of 69, she was considered among the most luxurious of the bay steamers. Offering overnight service between Norfolk and Baltimore, she was dubbed by some "The Queen of the Bay." (Kirn Library, Sargeant Memorial Room.)

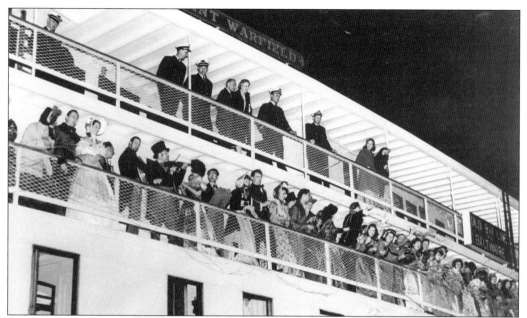

Costumed revelers participate in a celebration aboard the *President Warfield* at Old Point Comfort in 1940. Built at a cost of $960,000, she held 170 first-class cabins, expansive stairways and balconies, and paneled saloons in the style of the British. Pressed into war service, she served with distinction and eventually operated as a control ship at Omaha Beach in the Normandy invasion of June 1944. (Mariners' Museum.)

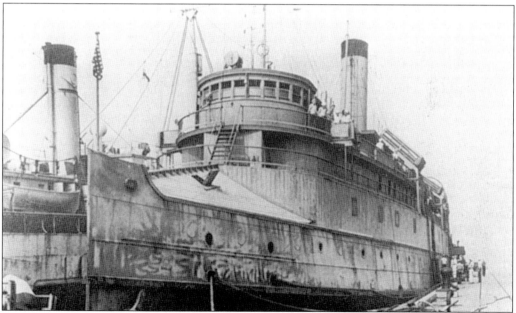

President Warfield was returned to Norfolk after the war. Her superstructure had been changed, and she had been fitted with four 20-mm guns. There was no desire on the part of the Old Bay Line to restore her to service. Consigned to a floating graveyard on the James River near Newport News, she was later, and mysteriously, recalled to life, refitted and next seen in the harbors of France and Italy. (Kirn Library, Sargeant Memorial Room.)

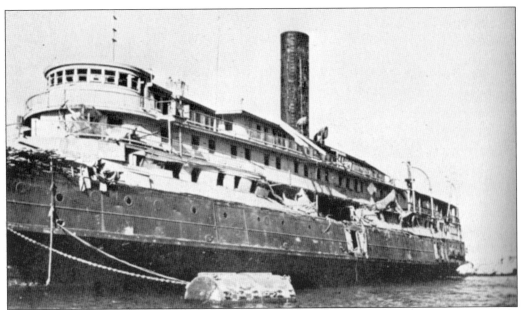

President Warfield returned to the world stage off the coast of France in 1947. Through proxies, she had been purchased by the Zionist organization Hagannah. In Sète, she had taken on 4,500 refugees of the Holocaust under her new name *Exodus* and headed out to return her Jewish passengers to their perceived homeland in British Palestine. The British, however, sought to prevent that immigration, and on July 17, she was rammed and boarded by British marines. (Mariners' Museum.)

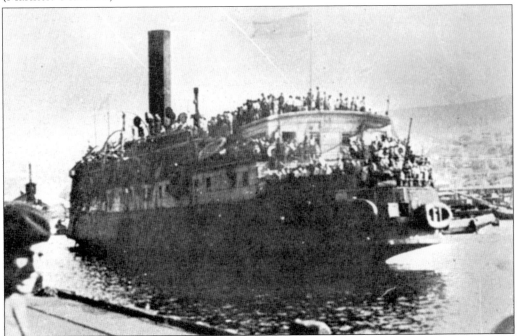

Exodus eventually arrived in Haifa harbor, where her passengers were forced into three British transports and returned to the German refugee camps from which they had started their attempts at emigration. Despite world attention, the journey of the *Exodus* had failed. (Mariners' Museum.)

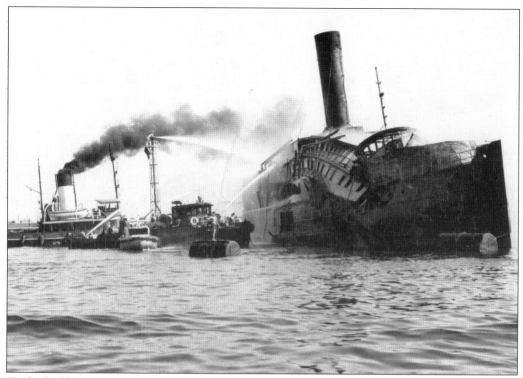

Exodus had become a symbol of the emergence of what would become the State of Israel, and in later years, she would become the subject of a popular book, movie, and theme song. But she had been effectively abandoned in Haifa harbor, and on August 26, 1952, the former Queen of the Chesapeake Bay burned to the water at the far end of the Mediterranean Sea. (Mariners' Museum.)

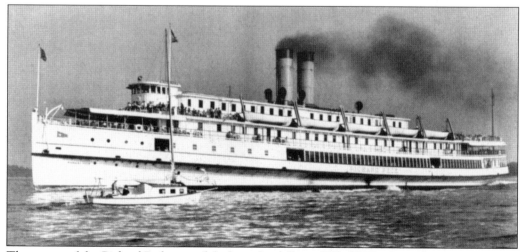

The career of the *Richard Peck* exemplified another effect of World War II on the story of the bay steamers. Those that were recruited into the war effort and survived often came back under new identities, to be used for different purposes. Those purposes often reflected the new realities of bay commerce. (Mariners' Museum.)

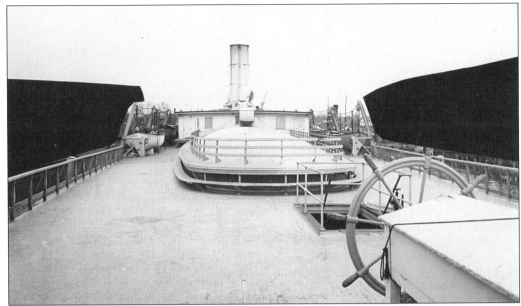

Seen on her afterdeck in 1943, the *Richard Peck* was already more than 50 years old. She had started her career as a night boat between New York City and Providence, Rhode Island. Designed by famed naval architect and artist Archibald Cary Smith and built by Harlan and Hollingsworth, she was one of the fastest—and considered the most attractive—of the boats on Long Island Sound. (Cape Charles Historical Society.)

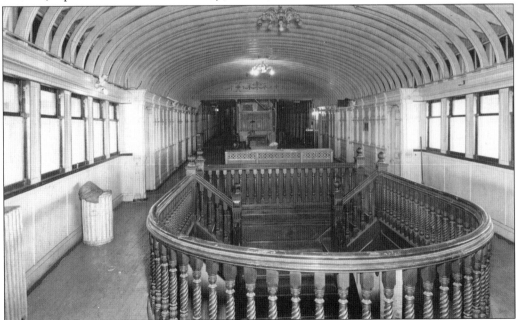

In 1937, most of *Richard Peck*'s staterooms were gutted, and she was converted to an excursion boat between New York and Connecticut. In 1943, she was brought into the war as a barracks ship stationed in Newfoundland, but her heating system proved inadequate for the climate, and she was sold, as seen here looking aft through her saloon, to the Pennsylvania Railroad. (Cape Charles Historical Society.)

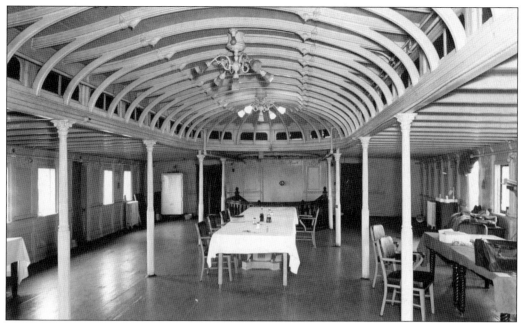

The war had put a damaging strain on the PRR ships used to ferry rail passengers between its train from New York and the naval town of Norfolk. At times, troop trains were backed up for miles on the Virginia peninsula waiting to deliver uniformed passengers to the overworked ferries. *Richard Peck* was refurbished by the PRR to be integrated into the route across the mouth of the Chesapeake Bay. (Cape Charles Historical Society.)

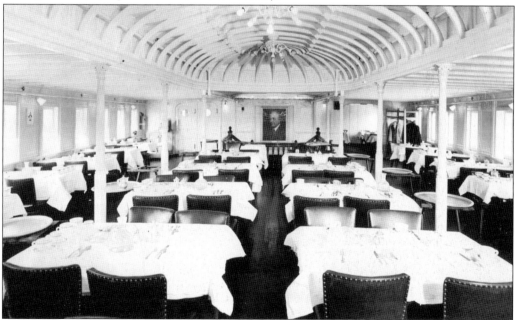

Richard Peck emerged on March 17, 1944, as the *Elisha Lee*, named after a deceased vice president of the railroad whose portrait hung at the head of her dining saloon. The crossing between Cape Charles and Norfolk could take up to three hours if a stop was made at Old Point Comfort, plenty of time for a relaxing meal at sea. (Cape Charles Historical Society.)

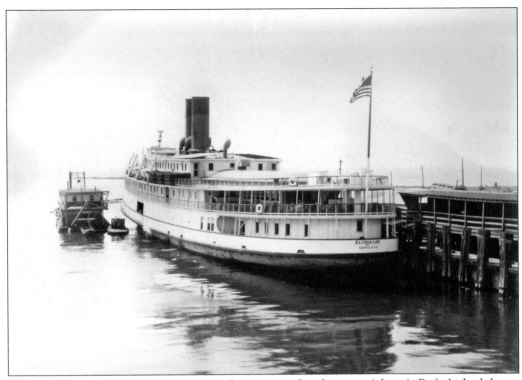

Elisha Lee rests at the dock at Cape Charles in an undated picture (above). Refurbished, large, and very comfortable, *Elisha Lee* became a favored meeting place and a place to conduct business between Virginia's Eastern Shore and its largest city to the south. Only a few of those in this picture of a 1940s meeting of the Eastern Shore Rotary Club are identified and without clear reference to location. Among them are Herman Watson, owner of the Texaco station in Onley; J. R. Leaman, owner of the Ford dealership in Cape Charles; superintendent of schools Ashby DeHaven; Mr. Keane, an insurance agent in Onancock; and department store owner James B. Wilson. (Above: Eastern Shore of Virginia Historical Society; Bottom: Cape Charles Historical Society.)

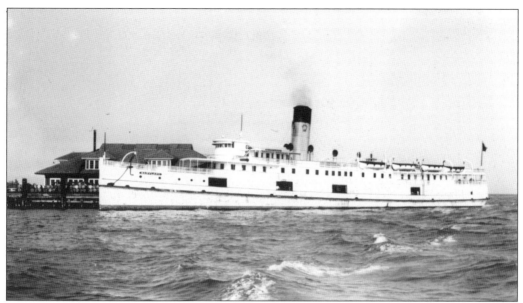

Maryland was the last of the steamers built, in 1907, specifically for the New York, Philadelphia, and Norfolk Railroad, later the PRR. Seen at Old Point Comfort in 1946, she was 249.5 feet long, 40.1 feet wide, and running with 1,900 horsepower. *Maryland* and *Elisha Lee* worked together on the Norfolk–Cape Charles crossing during the war. In 1944, the two combined carried 1,104,600 passengers. By 1949, *Maryland* had worn out and was taken from service. (Cape Charles Historical Society.)

Passengers enjoy the bay winds on the *Accomac* in 1956. She had been the PRR's *Virginia Lee* before the war and the flagship of the fleet. Wartime service turned her into a rubber transport on the Amazon River, and she went through various postwar owners before returning to bay ferry service, named after the Eastern Shore's Accomac County. (Cape Charles Historical Society.)

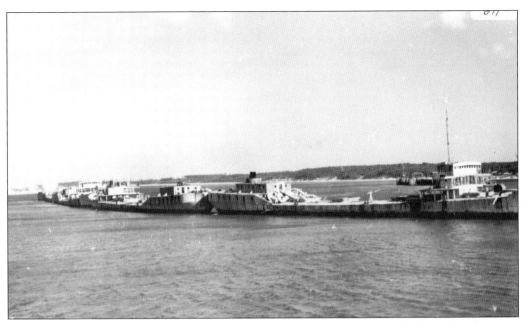

Another result of the war was the manufacture of 24 battleships constructed of reinforced cement for the U.S. Maritime Commission. Cement technology of the time allowed the production of hard ships that were remarkably buoyant. After the war, many of them became breakwaters around the country, including these at Kiptopeke harbor near Cape Charles in 1954. (Courtesy Robert Lewis.)

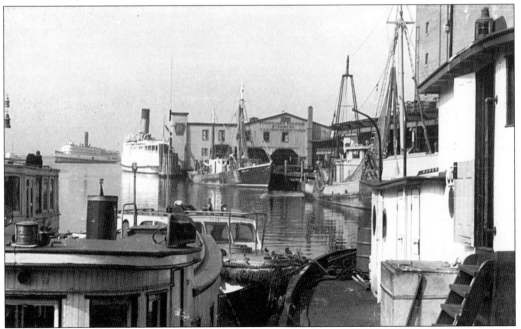

By 1949, calm and postwar prosperity had returned to harbors of the Chesapeake Bay. The PRR piers in Norfolk, seen here, were still in business, and the larger boats still arrived from Washington and Baltimore on a regular basis, but the era of the bay steamers was entering its final years. (Kirn Library, Sargeant Memorial Room.)

Seven

The Old Ladies

The *Elisha Lee* leaves the Eastern Shore and heads out of port toward a troubled sky in 1953. The melancholic tone of her departure matched the sense of the time that the era of the bay steamers would soon be coming to a close. World War II had played havoc with the strength and condition of the steamer fleet, and it had sped the development of highways and bus and truck lines that could move people and freight more quickly. The railroads that fed and supported the steamer lines also found themselves in decline. This may be a picture of *Elisha Lee*'s last run on February 28, 1953. She was due for a Coast Guard inspection the next day and expected to fail. Indeed the inspection identified $600,000 in needed repairs, and she was scrapped. (Eastern Shore of Virginia Historical Society.)

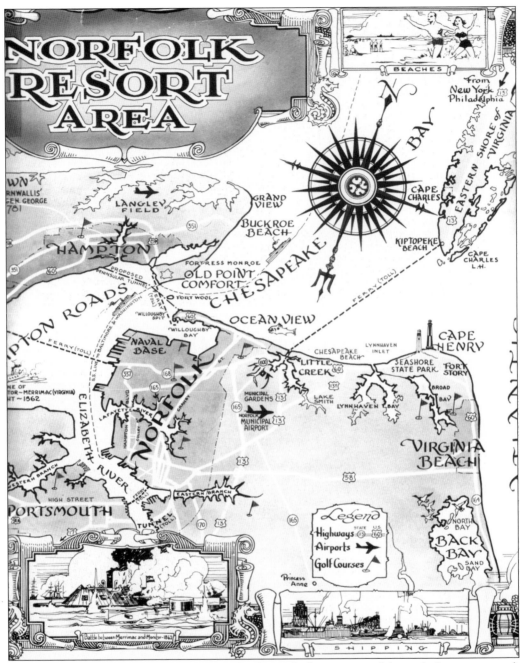

This map of the Norfolk Resort Area, *c.* 1950, shows the beginnings of the end of steamer travel. Airports were developing, and highways were increasingly important. Ferry boats that had crossed water for hundreds of years were about to be replaced by bridge-tunnels. The proposed tunnel between Hampton and Ocean View in Norfolk would replace an auto ferry in 1957. Not envisioned at the time of the map was the Chesapeake Bay Bridge Tunnel between a point near Cape Charles and Little Creek in 1964. Crossings of the water in Hampton Roads were always bridge-tunnel combinations so that in time of war, bridges could not be felled into the water and block the passage of ships of the U.S. Navy. (Kirn Library, Sargeant Memorial Room.)

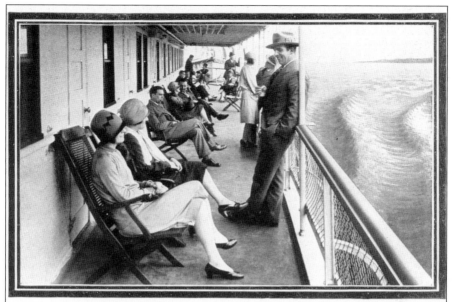

Happy Hours on Deck

Keeping Apace With Time

*I*T has always been the policy of the Old Bay Line to pioneer in all new inventions or ideas that would perfect its steamers and add to their comfort.

Each year has brought improvements in methods of construction and engineering. From the picturesque and quaint old side-wheel steamboats "Pocahontas." "Georgia" and "South Carolina." which were built in 1840, have evolved such new steamers as the "State of Maryland" and "State of Virginia." which have been likened to floating modern hotels.

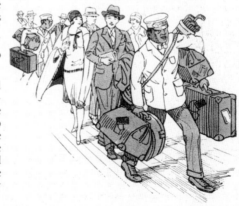

As the following pictorial story gives only a slight conception of the service on these new steamers. an actual trip will convince you that the warm old courtesies of the South will be found on board and that these steamers are the finest ever inaugurated in bay service.

The last 30 years of the Old Bay Line offer a good portrait of the end of the era. By 1935, the line, begun as the Baltimore Steam Packet Company, was nearly 100 years old but "Keeping Apace With Time," according to this brochure. Steamer travel was a mix of fun and casual elegance. New technology and new boats promised the coming of a golden era as the Depression receded. And in the case of the Old Bay Line, the promise of Southern hospitality was combined with a certain sophistication in which gentlemen still wore hats, even in the wind of the bay. (Kirn Library, Sargeant Memorial Room.)

THE Pilot House, where capable officers hold nightly vigil, guiding the steamer safely to port.

The Engine Room, the heart of the steamboat, where softly throb the powerful engines that propel her swiftly on to her destination.

LIBERTY ARCH, NEWPORT NEWS, VA.

As had been the case going back to the beginning of the steamer era, it still seemed important to point out the safety of the experience and the competence of the crew. Officers were "capable" and the jazz orchestra was "well trained." (Kirn Library, Sargeant Memorial Room.)

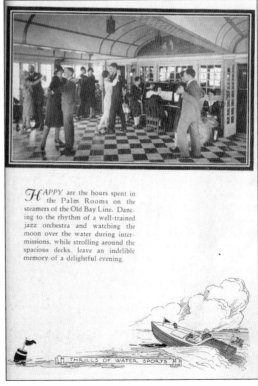

HAPPY are the hours spent in the Palm Rooms on the steamers of the Old Bay Line. Dancing to the rhythm of a well-trained jazz orchestra and watching the moon over the water during intermissions, while strolling around the spacious decks, leave an indelible memory of a delightful evening.

THRILLS OF WATER SPORTS

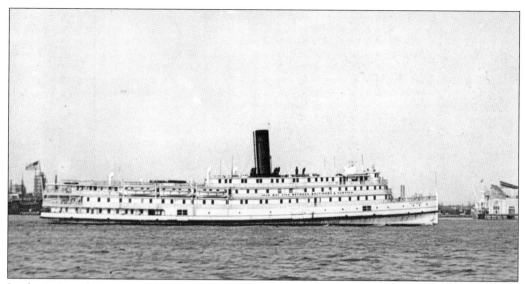

In the 1930s, the Chesapeake Line's *City of Norfolk* and Old Bay Line's *State of Maryland* were constant traveling companions and competitors on the bay. *City of Norfolk* would enter the Old Bay Line fleet in 1941 when the two companies merged as the result of decreasing business for both of them. On the evening of August 22, 1933, as a hurricane hovered off the coast of Hatteras, North Carolina, both left Baltimore harbor for their overnight runs to Norfolk. Following an unexpected path, the hurricane soon came blowing up the bay. *State of Maryland* fell into a pattern of lifting and pounding in oversize swells and troughs of the water. Much of her interior contents were destroyed, and her passengers rightfully feared for their lives. Behind her on the bay, *City of Norfolk* seemed to have the good sense to go safely aground on the Eastern Shore. *State of Maryland*, however, saw facing the hurricane head-on as her best option. She arrived safely at Old Point Comfort in the morning, only to find the wharf under water. (Maryland Department, Enoch Pratt Free Library.)

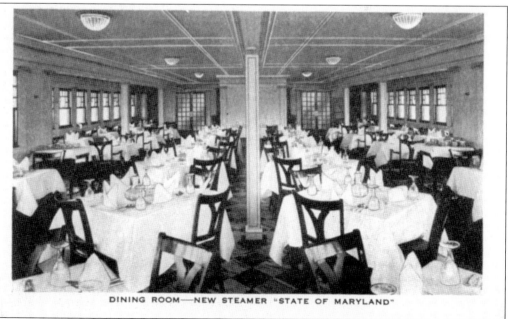

DINING ROOM—NEW STEAMER "STATE OF MARYLAND"

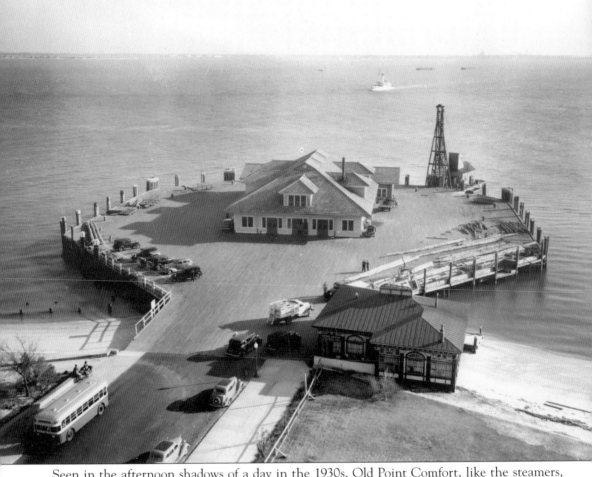

Seen in the afternoon shadows of a day in the 1930s, Old Point Comfort, like the steamers, seemed to be on a melancholy path. The view is probably from the top of the Chamberlin Hotel and looks south across the bay at the Norfolk Naval Base (upper right) before the coming war. As the war approached, Fort Monroe became one of the most heavily gunned defense facilities on the East Coast, and it prepared to manage minefields and submarine screens in the waters that home-ported the country's largest naval force. The bus is heading into the city of Hampton, probably with a stop at Buckroe Beach. Buckroe had been a fishing camp before the Civil War and developed into an amusement park postwar, another attraction for those who traveled the steamers. (Casemate Museum.)

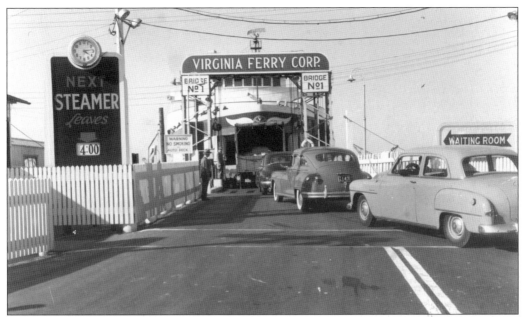

Bending to the postwar boom in the ownership of automobiles, the steamers expanded their capacities for cars, often to the detriment of space for passenger comforts. On April 27, 1951, the Virginia Ferry Corporation was loading a stream of travelers and their cars at Little Creek in Norfolk for transportation to the tip of Route 13 on Delmarva, where travelers could continue toward New York without using boats or trains. (Kirn Library, Sargeant Memorial Room.)

The *Wauketa* makes her last run for the Chesapeake and Ohio (C&O) Railroad from Newport News to Norfolk on June 4, 1950, looking every bit and more of her 48 years. Wauketa had been built in Toledo, Ohio, as a St. Clair River excursion boat between Detroit and Port Huron. She left Michigan in 1930, entered service for the C&O in 1944, and was broken up in 1952. (Kirn Library, Sargeant Memorial Room.)

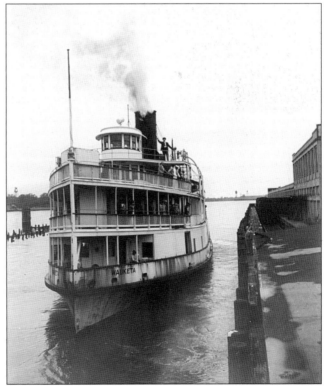

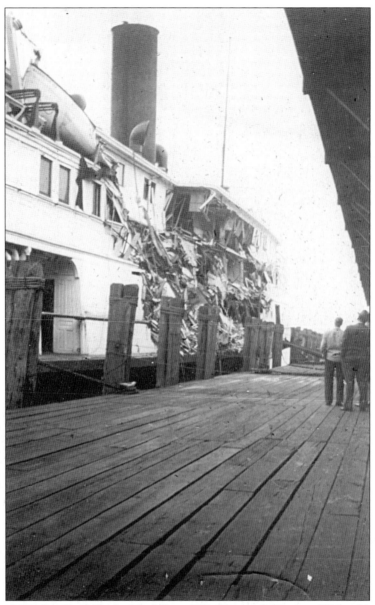

On the night of October 31, 1948, the Norfolk and Washington's *District of Columbia* collided with the tanker *Georgia*. A U.S. Coast Guard ruling that exonerated the steamer's captain describes the events in Hampton Roads Harbor: "[*District of Columbia*] encountered fog conditions which became rapidly worse until it was impossible to discern objects for a greater distance than one or two ship lengths. Regulation fog signals were being sounded by *The District of Columbia* and a very short time before the collision, the bell of a ship at anchor was heard bearing 4 or 5 points off the starboard bow, and within one-half or three-fourths of a minute thereafter the bow of the SS *Georgia* appeared out of the fog too close for Appellant [the captain] to take any action for the avoidance of collision. The bow of the *Georgia* contacted the starboard side of the *District of Columbia* about 100 to 150 feet from the stern. One passenger of the *District of Columbia* was killed." The collision put the Norfolk and Washington Line out of business. Also see page 87. (Wilson History Room, Portsmouth Public Library.)

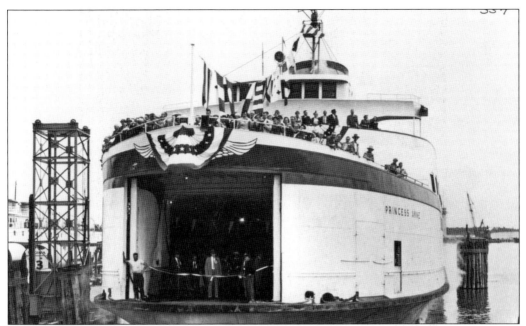

In the 1950s, a number of the older steamers, especially the steamers of the lower bay, were refitted to carry even more cars and trucks. In 1950, the *Princess Anne* was first reconfigured and inaugurated on the Cape Charles-to-Norfolk route with ceremonial bunting and a gaping hold for motor vehicles. Then in 1954, she was cut in half, and a 90-foot extension was added mid-ship. (Courtesy Robert Lewis.)

Pocahontas was a 1941 boat built for the Cape Charles-to-Norfolk route and the flagship of the fleet. In 1957, she was taken to the shipyard at Baltimore, broken in half, and fitted with a 76-foot extension. Seven years later, she would make the last run of the Norfolk–Cape Charles steamers. (Cape Charles Historical Society.)

Pocahontas was propelled by twin screws, one of them revealed in dry-dock. Typical of the time, she was originally 283 feet in length, 65 feet wide, and 16 feet deep. Original horsepower of 3,600 divided by two four-cylinder steam engines moved 1,962 gross tons through the water. (Cape Charles Historical Society.)

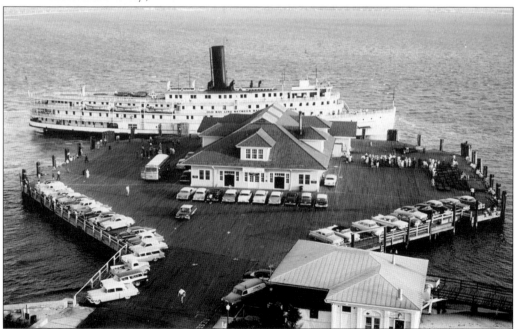

By 1958, the Old Bay Line and its *City of Norfolk* had already begun receding from the commerce of the bay. The company had been forced to use an inferior wharf in Baltimore Harbor. It reduced, and sometimes suspended, its schedules or limited its passenger capacity to reduce support staff. (Casemate Museum.)

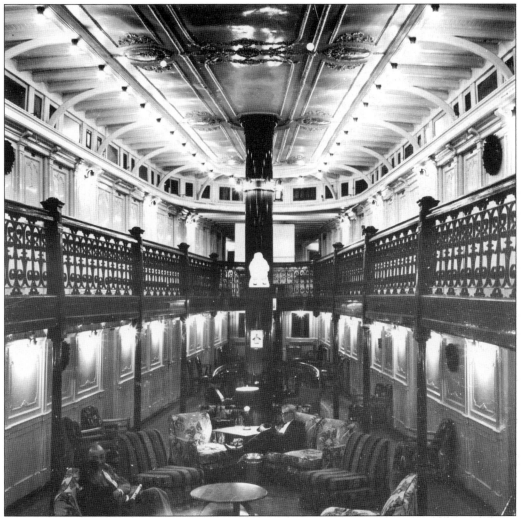

The *City of Norfolk*'s Grand Saloon was easily the most elegant living space to move regularly between Norfolk and Baltimore in the 20th century. In 1955, scheduled service for the *City of Norfolk* sent it out of Baltimore every other evening, alternating with the *City of Richmond*, departing at 6:30 p.m. Arriving at Old Point Comfort at 6:30 a.m. and Norfolk at 7:30 a.m. the following day, she would begin the return trip at 7:30 p.m., arriving back in Baltimore 12 hours later. Fares were $5 each way, plus $3.75 per person for a berth with private bath and up to $6.25 per person for outside cabins. Dinner started at $1.85 (the food was considered to be very good), breakfast at $1, and automobiles paid $7.50 each way. (Mariners' Museum.)

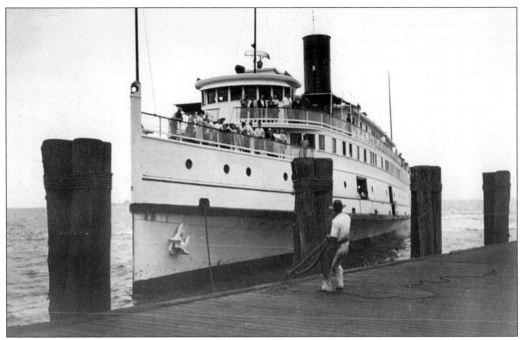

The currents and tides of the lower Chesapeake Bay were always of their own minds and especially so at Old Point Comfort. Often the captain of a docking steamer had to navigate her into a position 45 degrees from the wharf and let the tides push her the rest of the way. The direction and strength of the wind was always a factor. (Casemate Museum.)

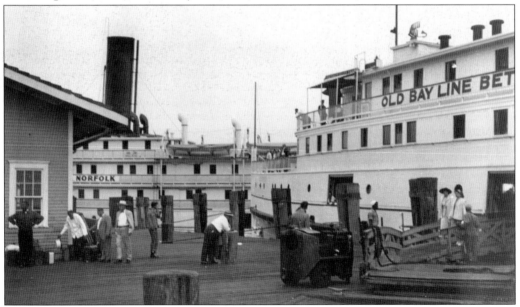

The *City of Richmond* (center) and the *District of Columbia*, by now a spare boat of the Old Bay Line, meet at Old Point Comfort. In 1952, Old Point Comfort was visited by 22,844 passengers of the Old Bay Line. In 1955, the U.S. Army began to fall behind in its maintenance of Government Wharf. The remnants of tropical storms and hurricanes during the 1950s battered the wharf as well. (Casemate Museum.)

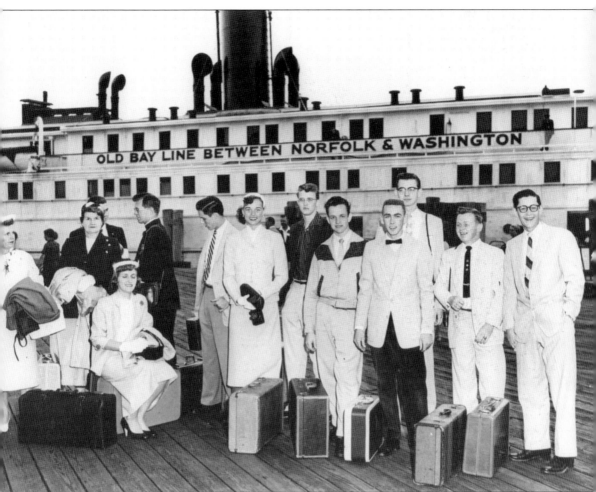

Members of the class of 1956 of St. Vincent's High School in Newport News had worked all year long, put on bake sales, and gotten some help from their parents to take this graduation trip overnight to Baltimore and then by train to New York City. "It was really something to be able to do that back then," according to Judy Volhein, seated on her suitcase. Others on the trip were, from left to right, chaperones Mrs. Earl Van Derlisk and Mrs. Dennis Antinori, accompanied by Robert Antinori, Rev. Donfred Stocker, Donald Durs, Nancy Hooper, Bucky Burt, Harvey Riley, Elvin Thompson, Walter Orr, Donald Brackin, and Donald Pons. It was the first trip to New York for each, and they toured the city for one week. In 2006, all but one were able to meet for their 50-year class reunion. (Casemate Museum.)

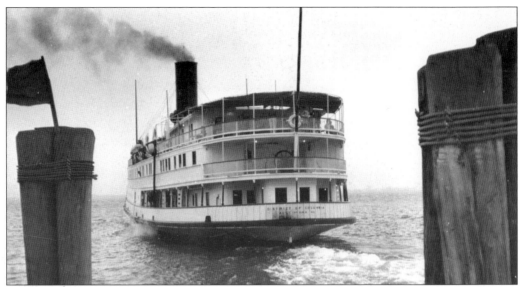

The *District of Columbia* is shown leaving Old Point Comfort in 1957, above. The last stop of a bay steamer at Old Point Comfort took place on the last day of 1959. Newport News *Times-Herald* reporter Ben Altshuler wrote: "The proud white *City of Norfolk* hove into sight shortly after 5 AM, a brilliant light on her tall mast taking the place of stars hidden by the cloudy dark December sky. She bit nearly straight into the cutting north wind as she rode to a last easy landing at the southeast edge of the octagonal wharf." Passenger Harry Bates recalled that his mother-in-law and her husband had honeymooned on the same ship in 1920. "Much of the good in life is the result of continuity," he said, "although the boat is something of an anachronism." There were those who wished that the city of Hampton could preserve the wharf as a historic treasure, but it was put in "Use at Your Own Risk" status and pulled up by order of the army on May 31, 1961. (Casemate Museum.)

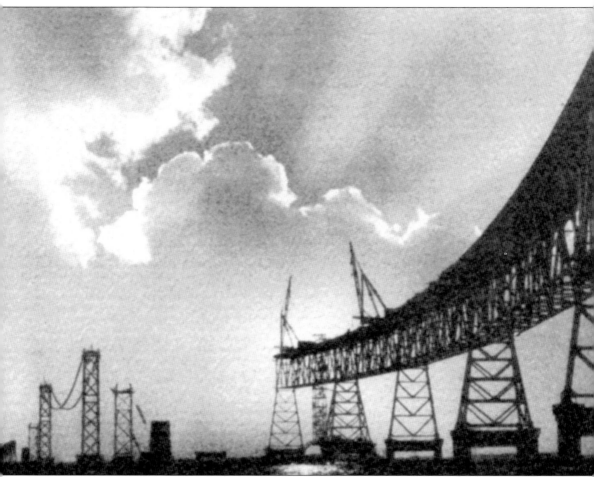

The steamers had been used to bridge the waters of the bay and, in the course of doing so, had created a community that included every small town and large city around the bay's perimeter. By the mid-20th century, the technology of bridge-building had developed to match the development of the automobile as the best tool for getting from here to there. Maryland had always been a state cut in half by a large body of water, but in 1949, work began on the Chesapeake Bay Bridge. at 4.3 miles, it would become the longest continuous over-water structure in the world. The $45-million, two-lane bridge connected Kent Island and Sandy Point, near Annapolis, and opened in 1952. (Maryland Room, Enoch Pratt Free Library.)

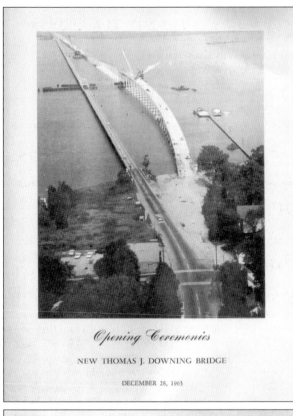

Opening Ceremonies

NEW THOMAS J. DOWNING BRIDGE

DECEMBER 28, 1963

The first, and more primitive, Thomas Downing Bridge (left) had been built near Saunders Wharf across the Rappahannock River in 1927 at a cost of $150,000. Its replacement, dedicated on December 28, 1963, raised the roadbed above the height of boats that used the river and allowed vehicle crossing unimpeded by a draw. (Essex County Museum and Historical Society.)

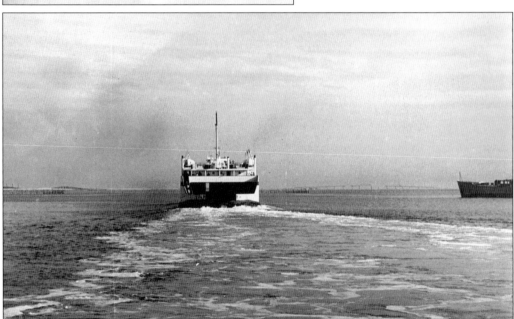

In 1963, the Kiptopeke Ferry was still in use carrying passengers, trucks, and automobiles from the tip of the Delmarva Peninsula near Cape Charles to Norfolk. But looming on the horizon off her bow was construction of the bridge that would put her out of business, the Chesapeake Bay Bridge Tunnel. (Eastern Shore of Virginia Historical Society.)

122

CHESAPEAKE BAY BRIDGE-TUNNEL

OFFICIAL GUEST PASS
FOR THE
OPENING CEREMONIES

CHESAPEAKE BAY BRIDGE-TUNNEL

April 15, 1964

Please report to the Shore Drive-In Theatre parking area. Present this pass to parking attendant. Retain pass to board a bus marked "SHORE DRIVE-IN THEATRE" for trip across Bridge-Tunnel. This pass admits one person.

At the time of its opening in 1964, the Chesapeake Bay Bridge Tunnel across the mouth of the bay became the world's longest bridge-tunnel complex. It cost $200 million to build and covered more than 17 miles of water. It quickly reduced the importance of ferries and steamers in bay commerce. With perhaps planned—and cruel—irony, the opening ceremonies took place on the *Pocahontas*, which was renamed *Delaware* two days later and moved to a route from Lewes, Delaware, to Cape May, New Jersey. (Cape Charles Historical Society, Eastern Shore of Virginia Historical Society.)

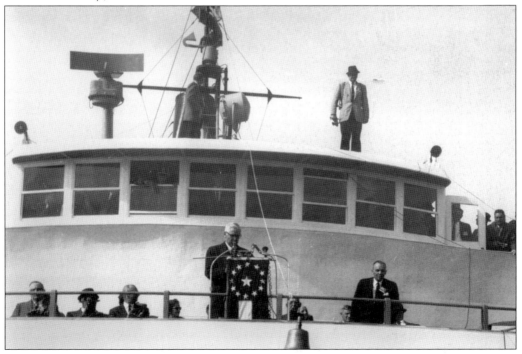

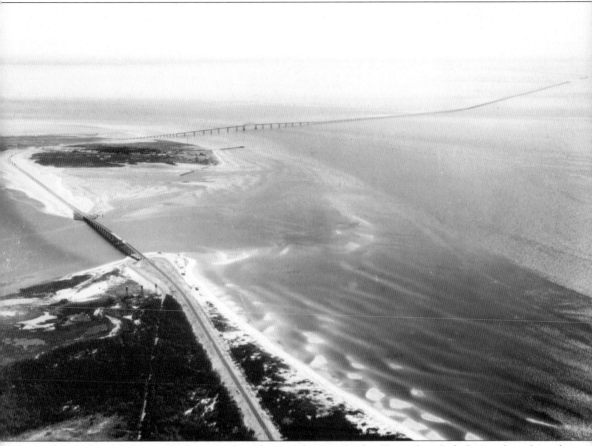

Seen from the tip of Delmarva, the Chesapeake Bay Bridge Tunnel included 13 miles of trestle and two miles of tunnel under each of two shipping channels toward Norfolk or Baltimore. It was deemed "One of the Seven Engineering Marvels of the Modern World" by the American Society of Civil Engineers. In 1999, a parallel bridge was opened that shared tunnels with the original. By the beginning of the 21st century, it had offered passage to more than 90 million vehicles. It effectively ended passenger ferry service across the bay from Delmarva to Norfolk, and it symbolized the end of one era and the beginning of another for bay transportation. (Cape Charles Historical Society.)

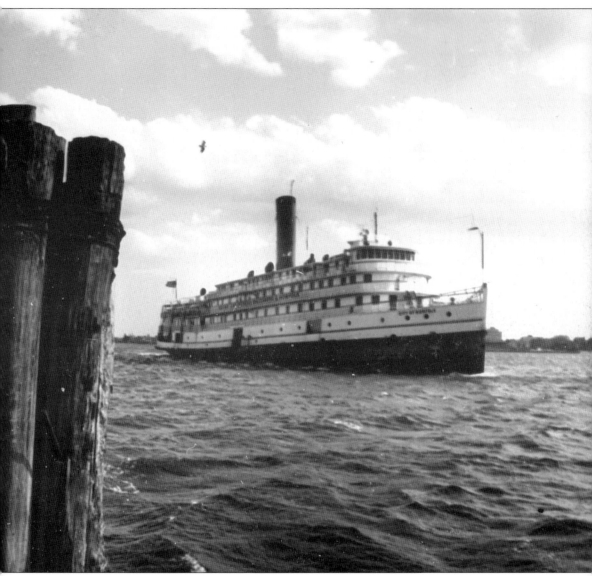

On April 13, 1962, the *City of Norfolk* pulled up to a dock in her namesake city for the final time, the last of the steamers on the bay. Captained by Patrick L. Parker, senior master of the Old Bay Line, she would be taken up the bay just once more, with only a bit of freight in her holds. Newspaper reports of the day mentioned various efforts to keep her alive, especially by a Baltimore civic group that had asked the governors of Maryland, Virginia, and Delaware for subsidies to keep her running in tourist months. "In any event," reported the *Times Herald*, "operation of the 'old ladies' as a regular service is ended." A month later, she would be towed out of Baltimore harbor to be broken down in a scrap yard. (Mariners' Museum.)

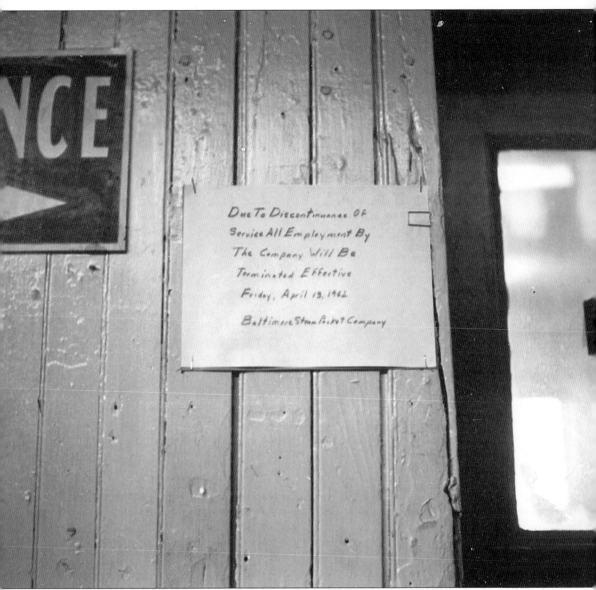

The era of the bay steamers had begun on June 13, 1813, with the excursion of the *Chesapeake* from Baltimore to Annapolis. It ended exactly two months short of 150 years later, reflected in a handwritten notice nailed to the wall in a doorway. (Mariners' Museum.)

INDEX OF PICTURED BOATS

ACROSS AMERICA, PEOPLE ARE DISCOVERING SOMETHING WONDERFUL. THEIR HERITAGE.

Arcadia Publishing is the leading local history publisher in the United States. With more than 3,000 titles in print and hundreds of new titles released every year, Arcadia has extensive specialized experience chronicling the history of communities and celebrating America's hidden stories, bringing to life the people, places, and events from the past. To discover the history of other communities across the nation, please visit:

www.arcadiapublishing.com

Customized search tools allow you to find regional history books about the town where you grew up, the cities where your friends and family live, the town where your parents met, or even that retirement spot you've been dreaming about.